IMAGES
of Modern America

BURIEN

D1604039

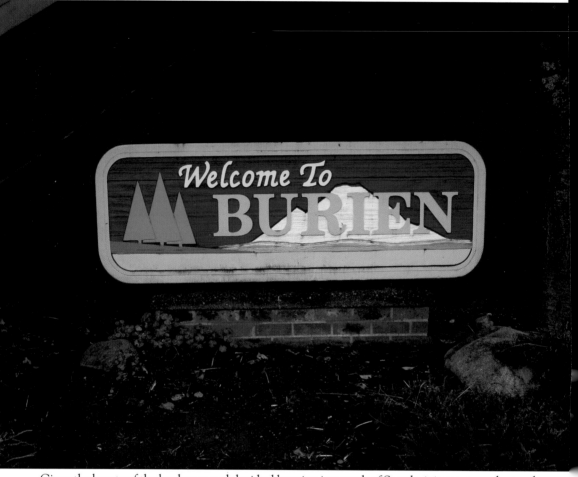

Given the beauty of the landscape and the ideal location just south of Seattle, it is easy to understand why Gottleib von Burian planted roots in the land that would eventually grow into the city of Burien. Incorporated in 1993, this gem of a small city sits perched on the edge of Puget Sound, just 15 minutes from SeaTac Airport. With a wealth of arts and cultural groups, an ethnically diverse array of shops and restaurants, a growing medical and wellness community, and a city that sponsors a number of public festivals and events throughout the year, Burien offers a wide range of experiences and opportunities for visitors and residents. (Courtesy of the author.)

ON THE FRONT COVER: (clockwise from top left) Overview of Town Square (page 83), jack-'o-lanterns nestled inside a sculpture at the Burien/ Interim Art Space (page 65), dawn over Puget Sound (page 21), Dia de los Muertos altar at the Night of 1000 Pumpkins celebration (page 66); and *The Passage* sculpture at the B/ IAS project (page 42).

ON THE BACK COVER: (clockwise from top left) Hydroplane in the Fourth of July parade, 152nd Street business district in 1940 (page 9), and Congressman Jim McDermott speaking at the opening of Towne Square and the King County Library (page 86).

IMAGES

of Modern America

BURIEN

Virginia H. Wright

ARCADIA
PUBLISHING

Published by Arcadia Publishing
Charleston, South Carolina

Printed in the United States of America

Library of Congress Control Number: 2014941894

For all general information, please contact Arcadia Publishing:
Telephone 843-853-2070
Fax 843-853-0044
E-mail sales@arcadiapublishing.com
For customer service and orders:
Toll-Free 1-888-313-2665

Visit us on the Internet at www.arcadiapublishing.com

*This book is dedicated to the many people whose passion in
the past and in the present has helped shape the character
of Burien, and to the citizens now and in the future whose
dedication will keep us on a path of growth and vitality.*

CONTENTS

Acknowledgments 6

Introduction 7

1. History and Links to the Past 9

2. The Abundant Beauty of Nature and Parks 19

3. A Thriving Community of Arts and Culture 33

4. Festivals and Celebrations 53

5. A Diverse Array of People and Commerce 67

6. Development and a Vision for the Future 83

ACKNOWLEDGMENTS

I would like to thank all of the generous local people who have contributed ideas, photographs, and encouragement for this project, including (in alphabetical order): Michael Brunk, the Environmental Science Center, EspressoBuzz, Robbie Howell, Steve Hughes, Dane Johnson, Larry Johnson, Kathy Justin, Scott Schaefer, Elmer (Bud) Sears Jr., and David Young.

I also offer a special note of gratitude to Christopher Wright, the most supportive spouse imaginable, whose patience while I was working on the book cannot be overestimated, and who contributed many excellent photographs. He also generously contributed his fine eye for wordsmithing to proofread the manuscript prior to submission.

Unless otherwise noted, all images were contributed by the author.

—Virginia H. Wright
Director, Burien Culture Hub

INTRODUCTION

Prior to February 28, 1993, when a popular vote led to Burien's incorporation as a city, the area south of Seattle, just beyond White Center, was one of several that were defined simply as unincorporated King County. Burien already had an identity more cohesive than a neighborhood prior to its incorporation, but the formalization into cityhood was a vital step toward building a better municipality.

Burien has grown in size and population significantly since its incorporation, adding 2,500 residents through the annexation of Manhattan and Woodside Park in 1998, and bringing on 14,000 additional citizens with the acquisition of a large portion of North Highline, between the northernmost city boundary and White Center (part of unincorporated King County). In 2013, Burien's population was estimated by the US Census Bureau to be 49,858.

Demographics in Burien changed along with this growth, with a notable increase in the percentage of citizens who identify as Hispanic, and a significant increase in the number of foreign-born residents.

In the past few decades, Burien has suffered a bad reputation among residents of neighboring cities in Puget Sound. This largely resulted from the financial distress of the city in the wake of Boeing's economic downturn in the 1970s, when many Boeing employees living in Burien lost their jobs. To longtime residents, or anyone who grew up in Burien, the impression that outsiders formed of Burien was unfounded and failed to take into account the rich history and long-term good in the city. Burien has been rising above its reputation for years, as more people recognize the many assets the city has to offer.

This book is by no means an exhaustive history or description of our charming small city on the Sound. My hope is that, for readers already familiar with Burien, this book will serve as a citywide scrapbook of memories. For new residents and out-of-towners, it is intended as a broad introduction to the city, showing where Burien has been—particularly within the last few years of significant change—and where Burien is now.

Since it was not possible within the span and scope of a book this size to cover every nuance and detail of Burien and its citizens, the focus has been on the elements of recent history that would be most interesting to readers. If this book gives readers the general sense of Burien's richly diverse community and inspires them to find out more, I have succeeded.

Sunnydale was the name originally used to identify Burien by non-native settlers in the 19th century. Some older residents still use the previous name, and it can be found in the names of several businesses and institutions, including Sunnydale Elementary School at Des Moines Memorial Drive and 156th Street.

One

HISTORY AND
LINKS TO THE PAST

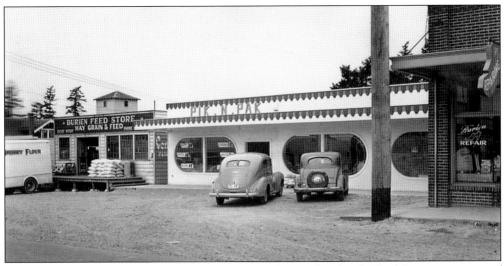

Taken on April 16, 1940, this photograph shows the north side of 152nd Street, just west of Ambaum Boulevard, in the business district now referred to as "Olde Burien." As seen on the next page, the buildings are still standing, although some of the architectural features have been altered over the years. (Courtesy of King County Archives.)

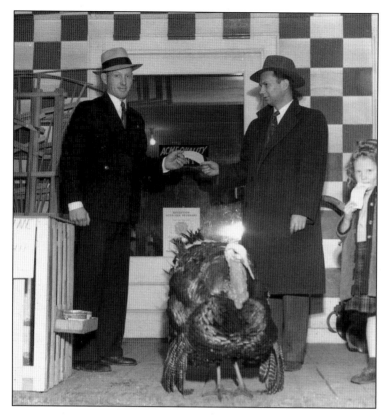

The winner presents his ticket and accepts his prize in the Turkey Raffle, at either Burien Feed Store or Hester Hardware, around 1950. The Burien of today has considerably fewer turkeys, but people still come from surrounding neighborhoods to buy feed for their livestock. (Courtesy of Elmer "Bud" Sears Jr.)

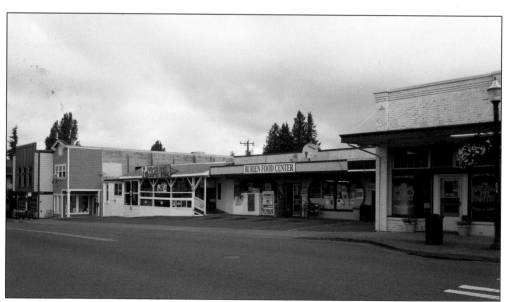

The 1960s and 1970s brought new construction and destruction. There are still a few places where the older character of the city survives, chiefly in the Olde Burien retail district. Historic architecture can be found in the residential areas, but very few late-19th-century and early-20th-century commercial properties still stand.

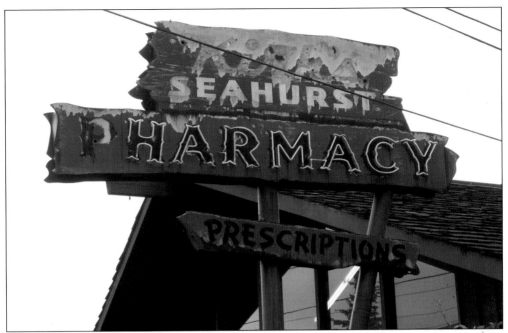

Mounted high, next to the building that formerly housed the Seahurst Pharmacy, this old sign is a reminder of what this part of the Seahurst neighborhood used to look like.

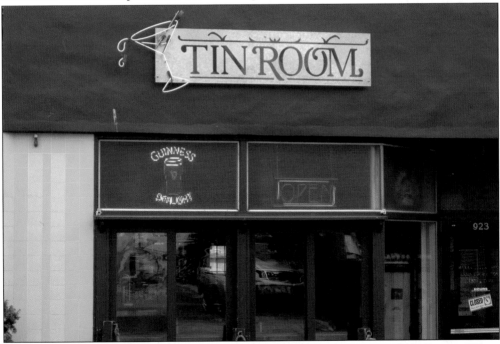

The Highline Tin Shop was a longstanding metal fabrication business in Olde Burien. When its owner finally decided to retire in 2002, local entrepreneur Dan "The Sausage Man" House transformed the space into a bar and restaurant, the Tin Room. He incorporated signage and some of the furnishings from the tin shop into his new business. Guests at the bar/restaurant now have the opportunity to see fragments of Burien's history while they visit the popular establishment.

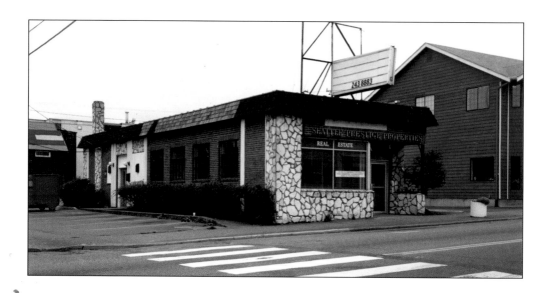

The above photograph shows the original Prestige Properties building at 152nd and Tenth Streets, which had a concrete plaque identifying it as "Post Office Burien USA." The below photograph shows the building as modified in the 1980s when architects were asked by Prestige Properties to add a second floor but retain the Olde Burien look and feel. The building later became the offices for Prudential Northwest Realty. (Both courtesy of Steve Hughes.)

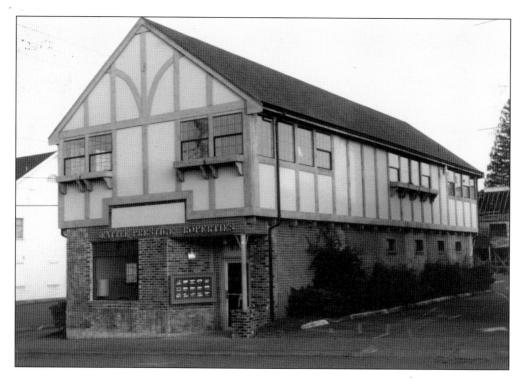

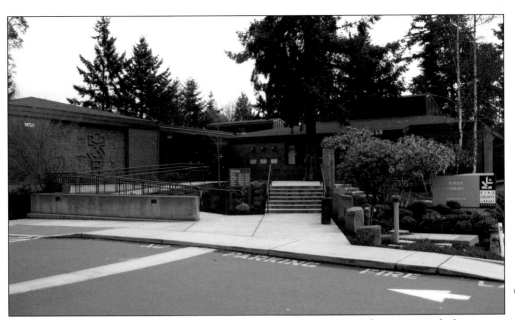

The building that originally housed the Burien branch of King County Library is typical of structures built in the 1970s, with Native American–inspired motifs incorporated into the surface of the outer walls and an inner courtyard with a fountain. After the Burien branch moved into its new building in Town Square in 2008, this building became the Burien Community Center. It remains a bustling facility, run by city staff and used by community groups for events and classes.

Tucked away in a less-traveled part of Ambaum Boulevard, the Highline School District Educational Resource and Administrative Center building is used for school administration and community meetings. This is one of the many public buildings in Burien that look almost exactly the same as when they were built a few decades ago.

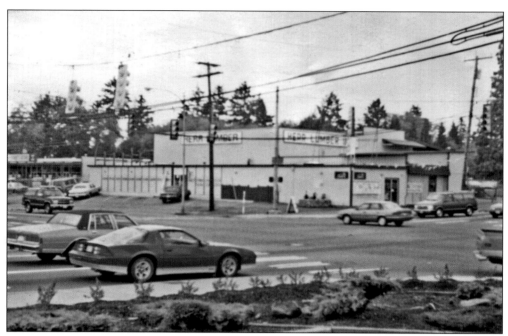

The Herr Lumber building, seen above in the 1980s, occupied the corner of 160th Street and First Avenue South beginning in the 1960s. It was opened to accommodate the expanding business enterprises of the Herr family. After a series of modifications and updates, Herr Backyard Garden was closed in 2012, and the property was leased as retail space to an antiques store. The same corner is seen below in April 2014, just before the building was demolished to make way for a CVS pharmacy. (Above, courtesy of the B-Town Blog; below, courtesy of Larry Johnson.)

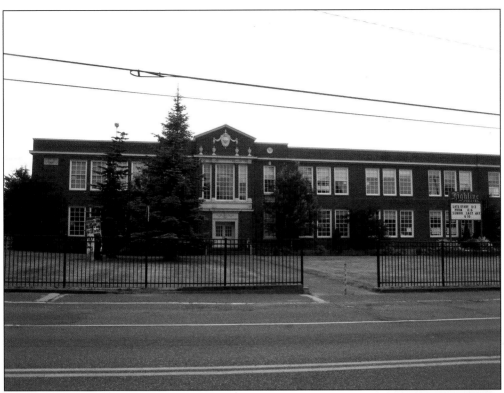

Opened in 1924, Highline High School is the only public high school in Burien. It has served generations of Burien kids. The building itself has changed very little since it was built, although additional facilities have been added, including the Highline Performing Arts Center, which is used by local performing-arts groups as a high-capacity venue.

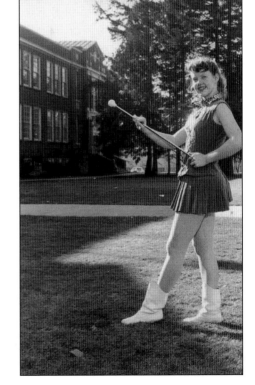

Historically, the Highline School District has provided a wide range of opportunities in all disciplines and has offered a large number of extracurricular activities for students. Here, a member of the drill team poses with her baton on the lawn in front of Highline High School around 1958. (Courtesy of Elmer "Bud" Sears Jr.)

Hiline Lanes is an example of a business that seems frozen in time, in appearance and function. In the second decade of the 21st century, several businesses are being constructed with a retro look. But there are areas in Burien that epitomize retro style, not by way of a trendy renovation, but by staying the same for decades.

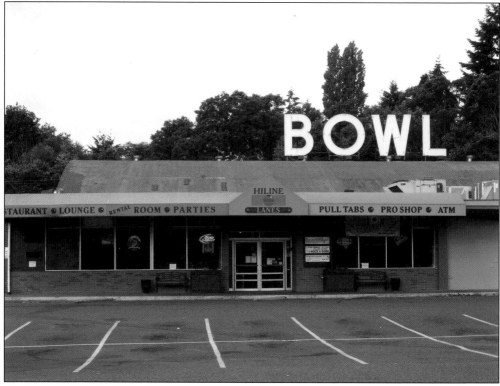

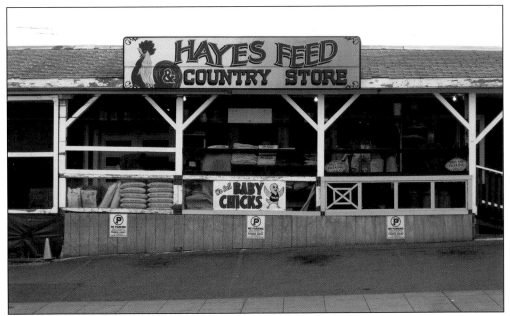

While a lot has changed around it, Hayes Feed has been the go-to place for supplies and animal food for generations of Burien residents. It is one of the only places within several miles where one can get chicken feed and the latest crop of chicks or ducklings, as well as hay by the bale. The business has operated under different names and owners over the years, but longtime residents still reminisce about visiting the feed store as children.

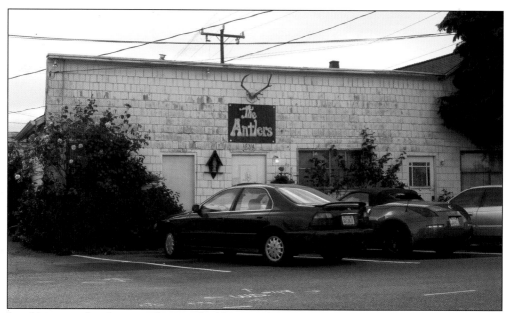

In addition to the charming historic buildings and shiny new architecture, there are a few odd, eccentric buildings around town. The Antlers, just south of the main drag in Olde Burien, looks more like a cabin in the woods than a house or commercial property. The front is decorated with a pair of the namesake antlers and a statue of the Virgin Mary. The rough shingled siding looks like it has been there since the 1940s, or even earlier.

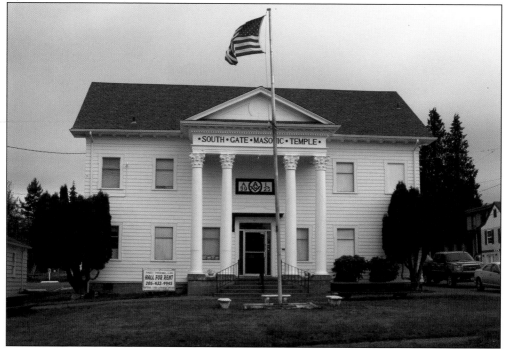

The South Gate Masonic Temple, located on 152nd Street just outside the official boundaries of Olde Burien, is the home of South Gate Lodge No. 100. In addition to its use for meetings and functions for the Masonic order, the building is rented out for events and gatherings.

Two

THE ABUNDANT BEAUTY
OF NATURE AND PARKS

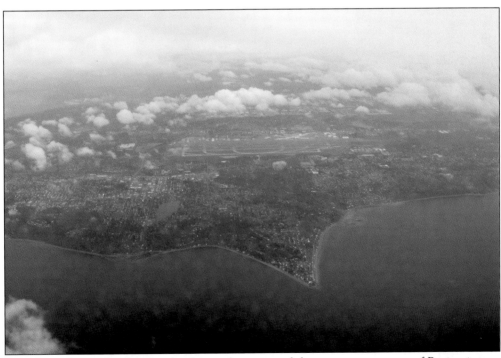

Seen from above, the dramatic and jagged contour of the westernmost part of Burien is very distinctive. Three Tree Point extends to the west, across the water from Vashon Island. Trees and other vegetation across the city provide shelter for a whole host of Pacific Northwest wildlife, including eagles, ospreys, owls, songbirds, crows, ravens, foxes, coyotes, raccoons, possums, and miscellaneous small rodents. Seals and sea lions inhabit the Puget Sound coastline.

Private residences surrounding Lake Burien are reflected in its still waters, while the much more recently constructed buildings of the Town Square development loom in the distance. Early construction and development in Burien centered on the small, beautiful lake. The lake is surrounded primarily by private residences, with the exception of the east edge, where the Ruth Dykeman Children's Center is located. Several Burien families have occupied the lake for multiple generations and have a deep connection to this placid, freshwater lake less than a mile from Puget Sound. The ring of closely knit houses conceals the lake from the surrounding neighborhoods, and many residents of Burien are unaware of it. (Courtesy of David Young.)

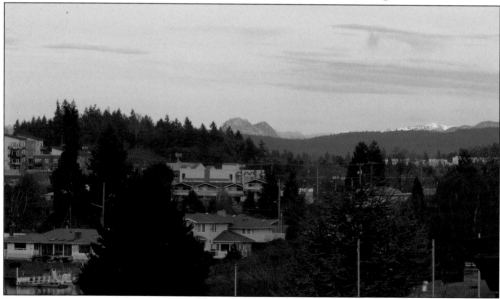

Looking north over Lake Burien and through downtown, it is possible to see Mount Si clearly in the distance. While the properties directly surrounding Lake Burien have not undergone much change in the last 40 years, this particular vantage point shows the recent construction that has significantly raised the skyline of the city. (Courtesy of David Young.)

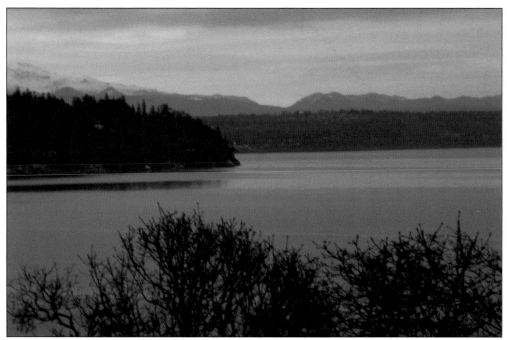

Burien is blessed with an incredible array of natural beauty: spectacular views from the hills overlooking the Puget Sound shoreline, rich wooded areas in the natural landscapes of city-owned parks, and the placid privacy of Lake Burien. The sky and waters at Three Tree Point are particularly impressive at dawn, when Mount Rainier is sometimes surrounded by luminous pink clouds. (Both courtesy of Christopher Wright.)

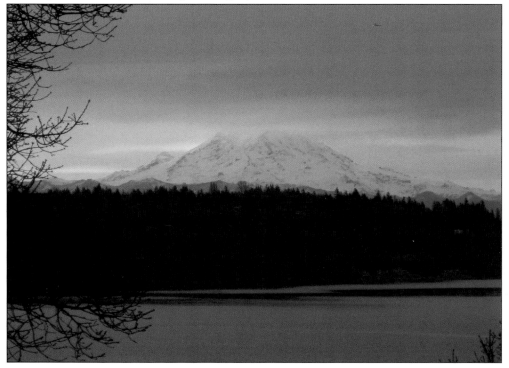

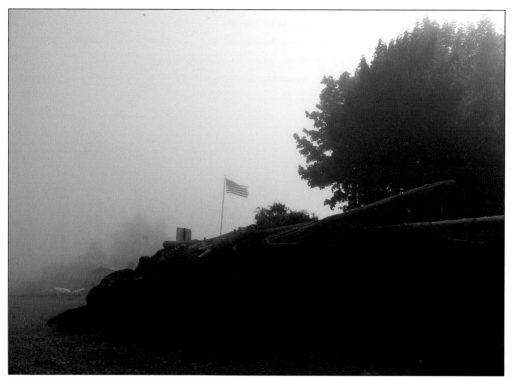

Looking at the tip of Three Tree Point in fog, it is easy to see how legends of mysterious creatures sprang up within the tribal stories of the Duwamish Peoples. Puget Sound can be shrouded in a dense fog for long periods of time, with loud foghorns broadcasting out of the grayness. (Courtesy of Christopher Wright.)

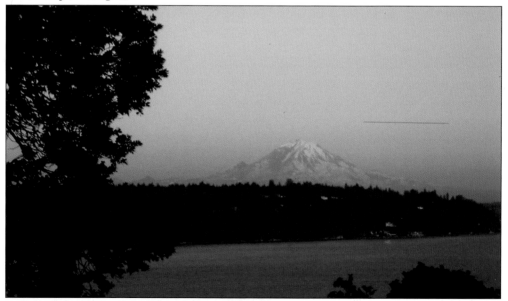

Called "Tahoma" by the original occupants of the Puget Sound region, Mount Rainier is an impressive feature, considerably higher than any of the surrounding peaks. The snow cover on this inactive volcano diminishes, but never fully melts, even in the warmest days of summer.

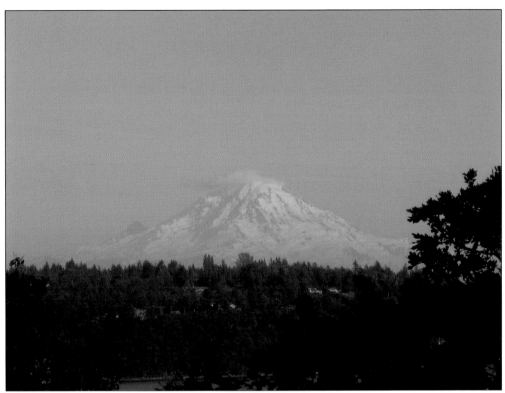

Depending on the time of day and the season, Mount Rainier takes on a wide range of appearances, and there are times when the mountain is almost entirely obscured by clouds.

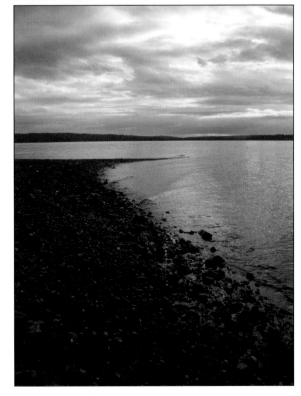

Broken up by islands, the waters of Puget Sound are quite calm in comparison to the Pacific Coast. The beaches on the Sound are rocky, and driftwood frequently appears. Low tide reveals clams and other low-profile sea life. (Courtesy of Christopher Wright.)

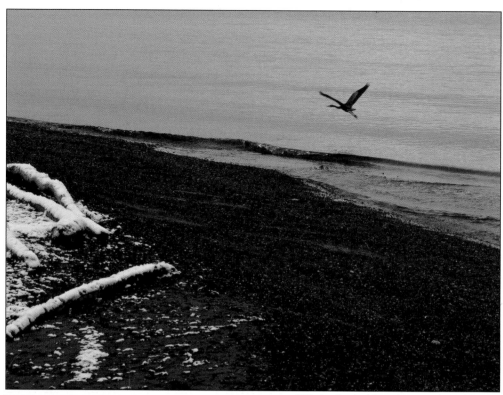

While the bald eagle is undeniably one of the more majestic birds that live in the area, great blue herons are also quite impressive. They are unmistakable, with their enormous wingspan and ability to stand stock still, knee deep in water, awaiting passing small fish. The heron snaps up the fish with its darting sharp beak and gulps the prey down its long and curvy throat. (Courtesy of Michael Brunk, NWLens.)

Most of the development on Three Tree Point in the late 19th century consisted of weekend cottages built for Seattle residents, when the "Mosquito Fleet" of ships carried passengers from Seattle to the Point and back. Many of those cottages are still standing, transformed into full-time homes. (Courtesy of Christopher Wright.)

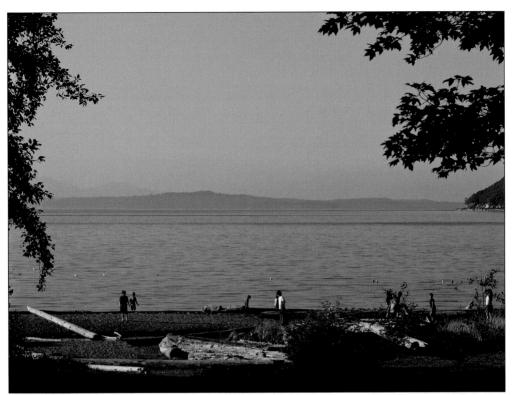

Just minutes from downtown Burien in any direction, there are extensive parks, with unspoiled wilderness and walkable trails. As pictured here, trails wind throughout Seahurst Park. (Above, courtesy of Michael Brunk, NWLens.)

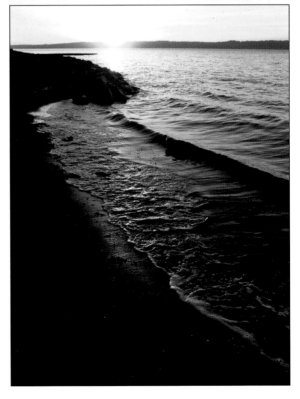

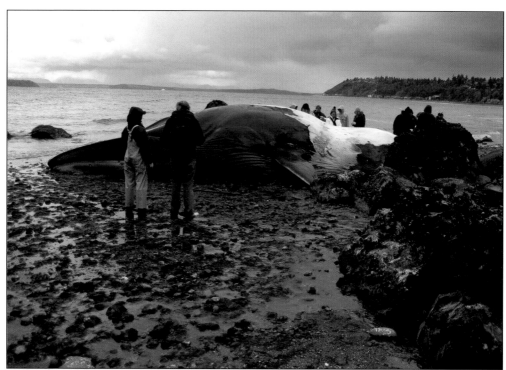

Objects that wash up on the beach along Puget Sound are usually small and unremarkable, but in the spring of 2013, the detritus on the beach included the major portion of a very dead fin whale. Many Burien residents and their dogs made the trek to Seahurst Park to see it in the days before it was removed. Lucky visitors were able to observe from a vantage point *upwind*. (Both courtesy of Christopher Wright.)

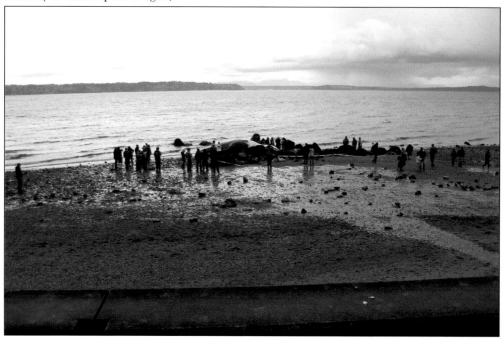

Burien usually has very mild winters, with an occasional dusting of snow that either does not stick at all, or is gone by the next morning. Once in a while, winter brings heavier snow showers that last for several days, making the steep and hilly areas of town quite treacherous.

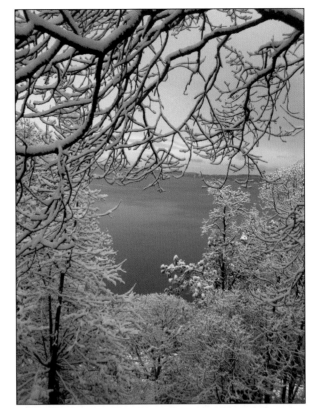

Evidence of some of the more secretive creatures that live in the area can show up in snow; otherwise, traces of these animals might never be seen. These are tracks of a short-tailed weasel. It is known as an ermine in places where there is an extended enough season of cold to change their coats from brown to white, as they never do here.

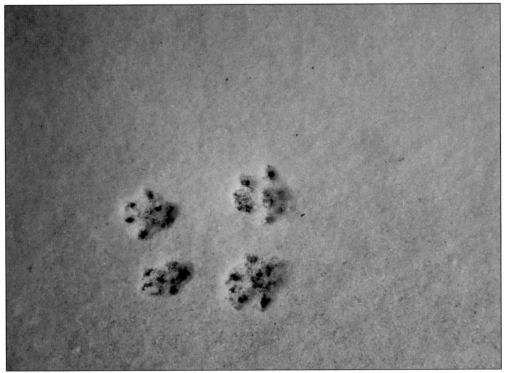

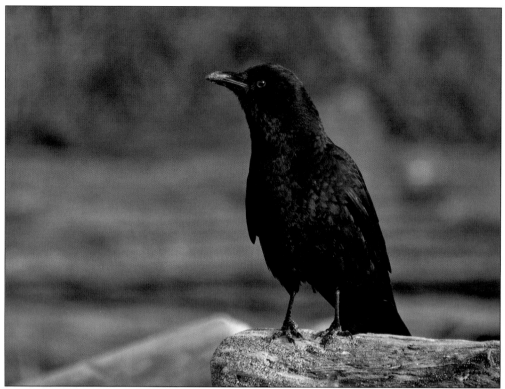

Crows are omnipresent residents of Burien. Large populations live close to the beach, where they walk along the water's edge, searching for the clams and crabs that make up part of their diet. Particularly in the spring, when pre-fledged crow babies are still defenseless against flying predators, crows serve as a reliable alarm system. Several of them swarm and scream when an eagle or osprey comes into their territory. (Courtesy of Michael Brunk, NWLens.)

With cinnamon-like bark and shiny dense wood, the madrona is one of the most distinctive trees in the Pacific Northwest, and Burien has many of them. While many of the madrona trees in Burien were damaged or even killed by a disease in the early 21st century, most have fully recovered and continue to thrive.

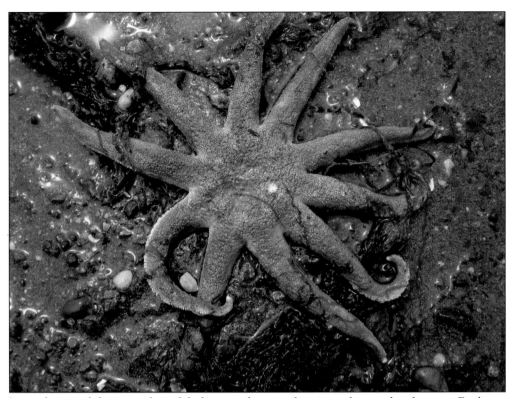

Low tides reveal the invertebrate life that spends most of its time submerged underwater. Explorers along the shore can see brilliantly colored starfish, crabs, and many empty clam shells. The waters just off of Three Tree Point are a popular diving spot, partially due to the rich variety of marine life, including the Pacific giant octopus and the six-gilled shark.

At certain times during the summer, the beach is littered with these curiously shaped objects, which look almost like errant strips of automobile tire. They are actually egg cases of the moon snail, a round, white mollusk.

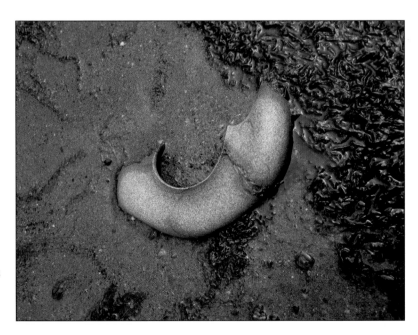

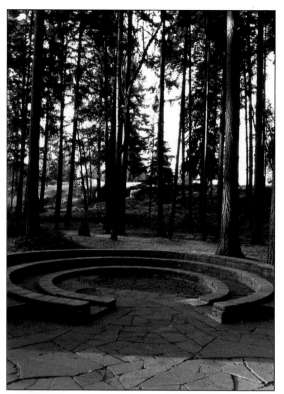

The concentric circles that form the pit in the center of Dottie Harper Park function as a small amphitheater, suitable for ghost stories on late summer evenings, or art installations, depending on the season. Originally called King County Park No. 10, it was renamed in 1995 to honor longtime resident and passionate community activist Dottie Harper. (Courtesy of Christopher Wright.)

Looking down through the dizzying array of metal staircases leading to the beach at Eagle Landing Park, one might be intimidated by the prospect of getting to the bottom and back up, but the stairs are winding and staggered enough to compensate for the steepness of the hill. The park is named for the eagles that are observed to nest there every year, but there is an array of other wildlife in the park, from ospreys to otters. (Courtesy of Christopher Wright.)

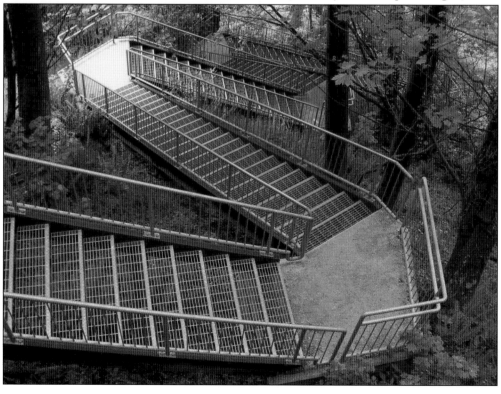

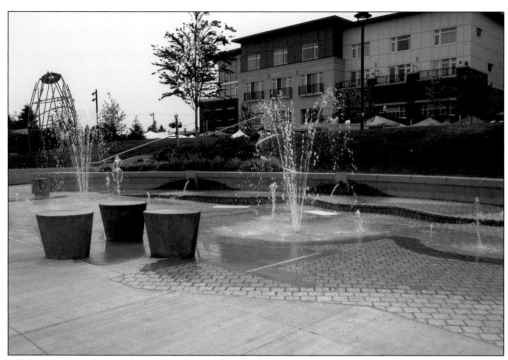

While Burien parks are notable for their rich wildlife and natural beauty, some have more playful elements, like this water park adjacent to the Burien King County Library. Here, kids can cool off in the summer among variably squirting jets of water.

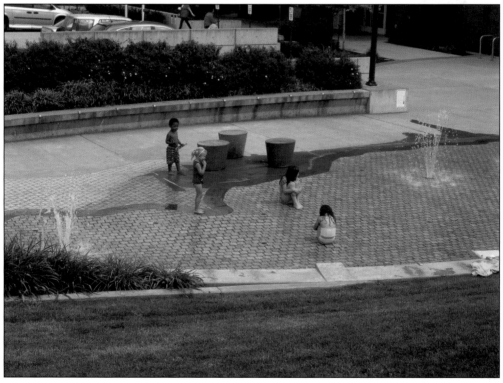

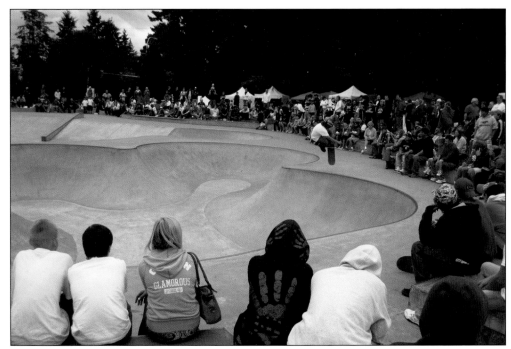

This skate park was built in 2001 in front of what was at that time the Burien Community Center. The collection of municipal buildings is now called the Annex, housing the rehearsal and performing space for The Hi-Liners and Burien Actors Theatre, as well as a range of community workshops and classes. The skate park remains a popular meeting place for kids and provides a fantastic opportunity for local youth to practice their tricks in a safe and appropriate setting. Throughout the year, there are almost always kids skating in the park.

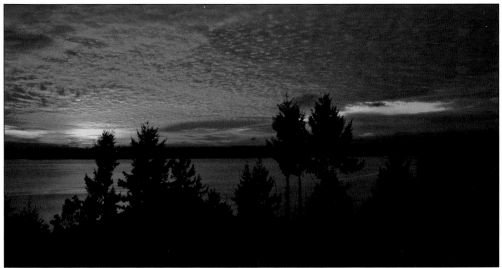

It is a hard call whether the view overlooking Puget Sound is more spectacular at sunrise or sunset, but either way, Burien residents are incredibly fortunate to be able to see such glorious skies. Newcomers to the area are always impressed by the gorgeous vistas, but even lifelong residents with families going back many generations never become so accustomed to the landscape that they fail to appreciate its beauty. (Courtesy of David Young.)

Three

A Thriving Community of Arts and Culture

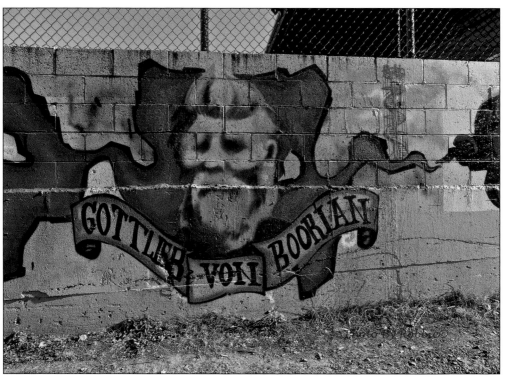

The arts are an important element of Burien's definition as a city, with a variety of visual and performing arts, as well as public art that is both created and sponsored by the city and by private groups and individuals. Burien also recognizes the value of its own history, and the importance of culture and heritage. (Courtesy of Robbie Howell.)

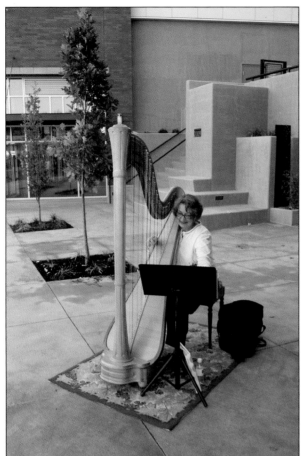

Seattle harpist Jini O'Flynn has brought her harp to Burien many times, helping to create the right atmosphere at events. Here, she performs at Arts-A-Glow, providing the atmosphere during the time before it gets dark enough to see the light-based works. (Courtesy of EspressoBuzz.)

Since 1966, the Hi-Liners have been working with youth from age 3 to 22, with musical theater classes, workshops, and performances presented to the community throughout the year.

In 1991, the Highline Performing Arts Center (PAC) opened this large performance hall to serve the needs of the public schools and to be used as a rental space. The PAC is owned and administered by the Highline School District and is the home venue for different local performing groups, including the Hi-Liners, Northwest Symphony Orchestra, Highline Community Symphonic Band, and the choirs of Northwest Associated Arts.

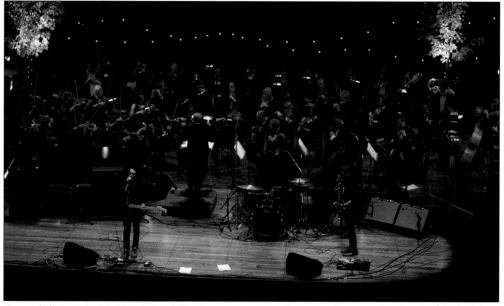

One of the arts groups to take full advantage of the large performance space of the Highline Performing Arts Center is Northwest Symphony Orchestra (NWSO), a full-sized orchestra headquartered in Burien. Under the baton of conductor Anthony Spain, NWSO has been presenting familiar classic repertoire alongside works by local Northwest composers since 1987. (Courtesy of Northwest Symphony Orchestra.)

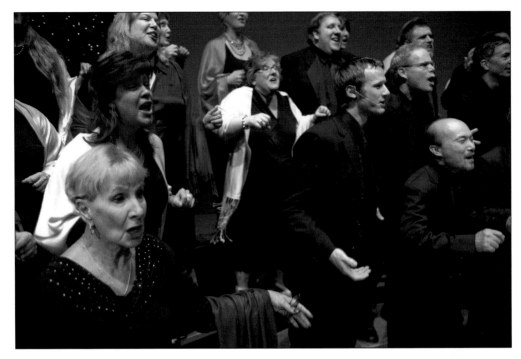

Northwest Associated Arts is the umbrella organization for a group of community choirs that performs several concerts a year. The singers in ChoralSounds Northwest, TeenSounds Northwest, KidSounds Northwest, and SilverSounds Northwest range in age from very young children to the elderly, giving singers of all ages the opportunity to participate in choral music. (Both photographs by Peter Lindström; courtesy of Northwest Associated Arts.)

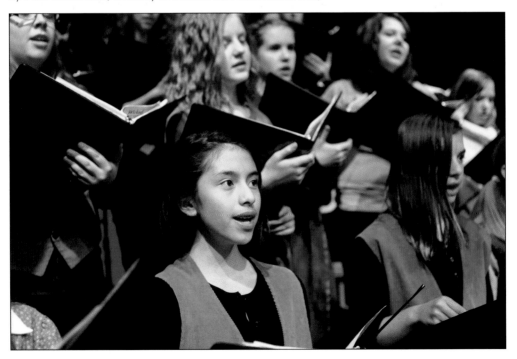

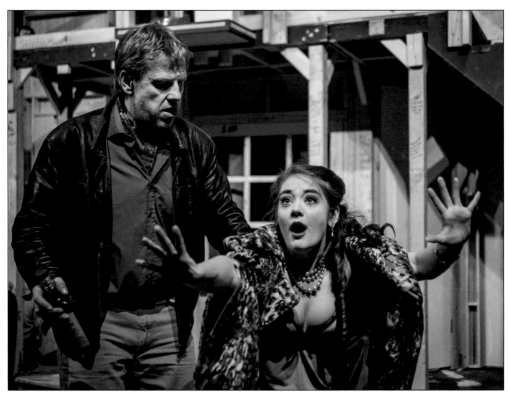

Burien Actors Theater (previously called Burien Little Theater) has been providing high-caliber theatrical performances in Burien since 1980. Under the passionate leadership of managing director Maggie Larrick and artistic director Eric Dickman, BAT presents multiple performances throughout the year and has collaborated on successful bilingual productions with Latino Theater Project. The above photograph shows a scene from *Noises Off*. A production of *Young Frankenstein* is seen below. (Above, photograph by Michael Brunk; below, photograph by Mike Wilson; both courtesy of Burien Actors Theatre.)

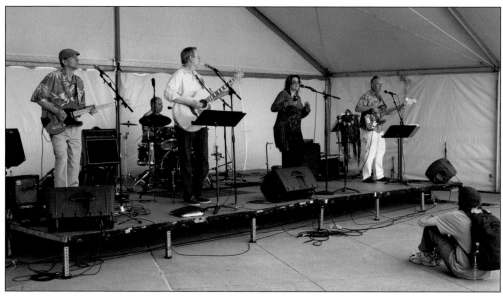

In addition to the more formal nonprofit performing-arts groups, there are quite a few bands and amateur musicians who perform at local establishments and events around town. Pictured performing on the main stage at the Wild Strawberry Festival is the band Cornerstone, frequently also seen at 909 Coffee & Wine in Olde Burien. (Courtesy of Leslie Stevenson-Johnson.)

Former Bad Company bassist Lynn Sorensen led Sunday night jam sessions at CC's Lounge, a local piano bar in downtown Burien. Local talent participating in these sessions included Jim Locklear, shown here at the microphone at the last of them, in March 2014. (Courtesy of Larry Johnson.)

Sharing space and publicity with the Wild Strawberry Festival, the annual festival of concert bands called Bandapalooza takes place in Burien during the weekend of Father's Day in June. The full bands perform on the main outdoor Bandapalooza stage, while smaller sub-ensembles, like this quintet of saxophonists, are scattered around town, playing to smaller crowds.

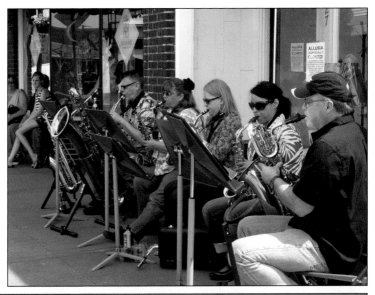

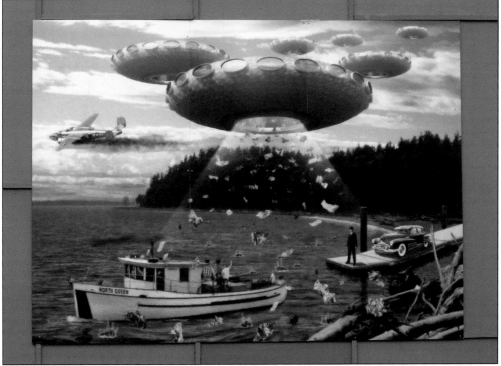

In 2013, a team consisting primarily of Tin Room owner Dan House, owner/editor of the B-Town Blog Scott Schaefer, screenwriter Steve Edmiston, and owner of local historical residence Forest Ledge John White, assembled to produce a short film, *The Maury Island Incident*, about what is said to be the first "men in black" event involving UFOs. The Maury Island incident, depicted in the mural pictured here, took place off Vashon Island in 1947, well before the more well-known happenings in Roswell, New Mexico. This well-documented series of occurrences allegedly consisted of a visitation by alien spacecraft, subsequent cover-up by the federal government, and a great deal of chaos and trauma in the lives of the people involved.

Burien's large Latino population includes a number of talented performers of traditional Mexican music, including this group, which took the stage during the Dia de los Muertos–themed Night of 1000 Pumpkins in 2008. (Both courtesy of Michael Brunk.)

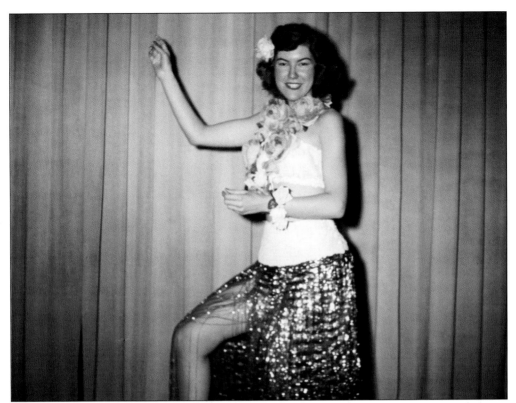

Local real-estate professional Robbie Howell (formerly known as Jean Scism) was an accomplished dancer and dance instructor. Here, she is shown performing a Hawaiian dance for Seattle B'nai B'rith in 1953. She has fond memories of participating in the arts, both throughout her early years in the Burien school system and also with the USO-sponsored groups sent to perform for troops at Fort Lewis and other military bases. (Both courtesy of Robbie Howell.)

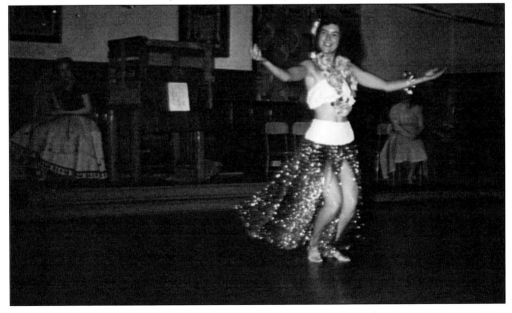

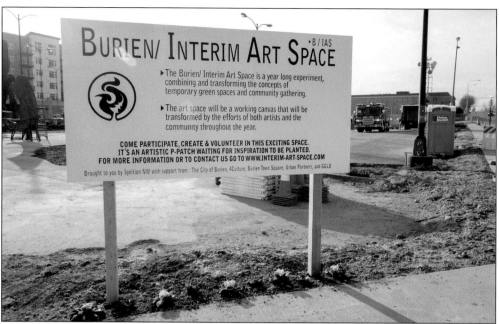

In 2008–2009, Burien hosted a revolutionary public art project called the Burien/ Interim Art Space (B/ IAS). Burien residents Dane Johnson and Kathy Justin facilitated the year-long project, during which they curated a collection of sculptural installations and performances on a one-acre parcel of land awaiting development. Today, the project serves as a model for revitalizing under-utilized space through temporary curation of the arts. (Courtesy of EspressoBuzz.)

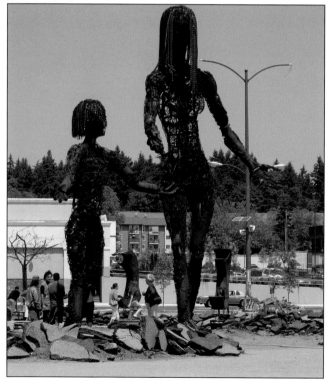

The pieces installed on the B/ IAS site exhibited a range of styles and scale, from a conservative piece easily imagined in front of an office building, to a delicate metal tree encircled by comfortable seating. The centerpiece of the site was Dan Das Mann and Karen Cusolito's two-story *The Passage,* a pair of figures constructed entirely of scrap and recycled metal. Liquid fire passed from the larger to the smaller figure through enormous steel fingers, symbolizing the transference of knowledge through generations. (Courtesy of EspressoBuzz.)

The idea for the B/ IAS project, pictured here during the Wild Strawberry Festival, was ignited by the far-reaching sparks of Burning Man, held in the Nevada desert every year. Dane Johnson and Kathy Justin had been faithful "Burners" since 2001 and were able to pull artists and artworks originally built for Burning Man for installation on the B/ IAS project site. Working with the City of Burien and 4Culture, King County's arts and heritage funding organization, the team skillfully assembled a coalition of representatives from Burien Town Square, Urban Partners LLC, 4Culture, the City of Burien, Ignition Northwest, and GGLO, the architecture firm developing Town Square.

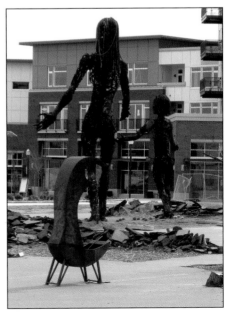

The B/ IAS opening in late January 2008 was an exhilarating burst of artistic fervor in the center of town, attended by 500 to 700 people, including a number who just happened by and felt compelled to stay and watch. The primary sculptures dramatically spewed and dripped fire, accompanied by DJs, fire dancers, and other performers. Burien had never seen such a spectacle, and response from the community was nearly unanimously favorable. (Courtesy of Christopher Wright.)

The Helios Pavilion in Town Square Park is one of the newer public art pieces in the city. In 2007, Seattle artist Dan Corson proposed a sculpture for installation in Town Square that was inspired in part by Gunther's Tower, an odd-looking overlook structure that spiraled around a tree in the early days of settlement in Burien. Corson's sculpture was deemed hostile, suggestive, and unwelcoming by many in the community and by a majority within the city council, and the plan was ultimately rejected. James Harrison's Helios Pavilion was chosen in its place. The piece was conceived as a tribute to the Duwamish tribe, which originally inhabited the land. In part, Harrison's artist statement reads, "In spirit, the sculpture is James' gift to the Duwamish tribe, to honor and celebrate the people whose culture infused the land long before the development of Burien was envisioned."

This salmon sculpture by Leslie Zenz is shown in one of the outdoor light-based art installations, located on the hill just outside of the King County Library, during the Arts-A-Glow Festival.

Burien Arts Association is actively involved in many local arts activities. After occupying two previous downtown locations, Burien Arts operated its gallery in the "little blue house" at Dottie Harper Park from 1974 through 2009, when economic circumstances resulted in closure of that space. A few years later, the group opened Burien Arts Gallery in Olde Burien (pictured), staffed in part through a collaboration with Artists United, a local club of amateur, professional, and retired artists.

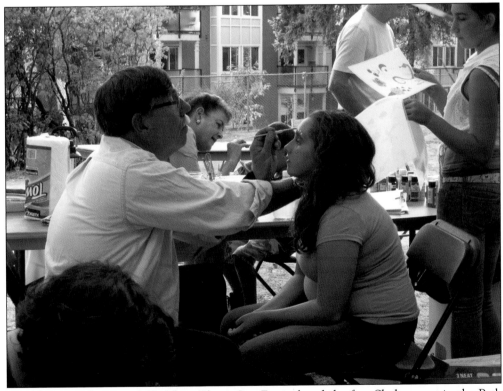

In addition to the annual Highline Classic Jazz Festival and the free Shakespeare in the Park summer performances, another of the ways that members of Burien Arts Association engage with the community is by providing face-painting services at outdoor festivals, like Arts-A-Glow and workshops and classes for kids. Here, trustee John Unbehend applies paint to one child as more kids enthusiastically wait to get fanciful and decorative designs to wear for the day.

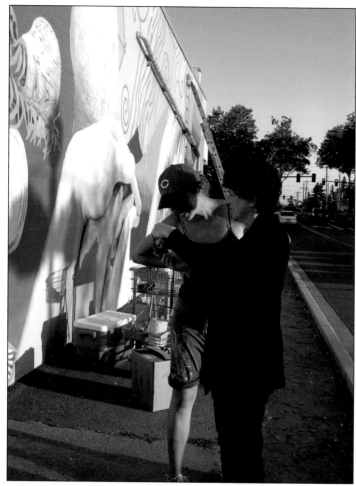

Burien's "1% for Art" program, which requires that one percent of the money from every public-works project be devoted to public art, has been responsible for the support and creation of a number of large-scale works throughout the community, including the *Sacred Circles* mural by Augustina Droze. Completed in 2012, the mural has transformed a formerly bleak and frequently defaced wall into a highlight of the city. Burien has recently completed a project of labeling each of the public-art projects in the city with bright, noticeable signage, with an accompanying printed brochure and additional information available online. At left, muralist Augustina Droze and arts commissioner Donna DiFiore consult during the creation of the piece.

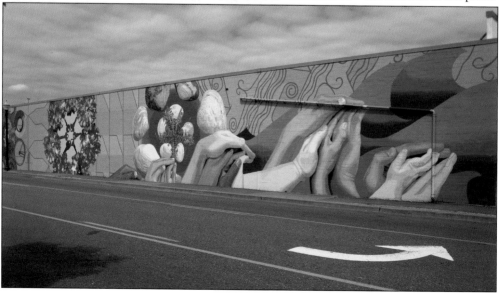

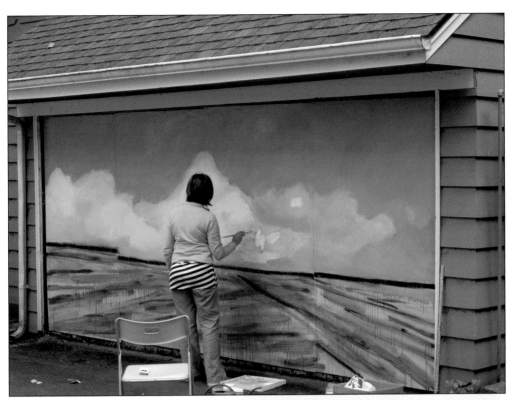

Some of the public art in Burien
is less permanent, like this mural,
painted as a temporary work during
the Wild Strawberry Festival.

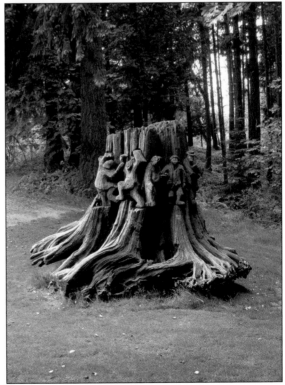

Dottie Harper Park has been host to
a great deal of art, both visual and
performance, including this sculpture
by Richard Beyer called *Ghost Dancing*
(sometimes alternately identified as
Wobblies Dancing), which was installed
in 1974. The central element of the
sculpture is an old-growth cedar
stump, with carved figures added to
"bring the tree back to life" through
their dancing around the trunk. The
sculpture, intended to be climbed
on, has experienced considerable
wear in the intervening years.

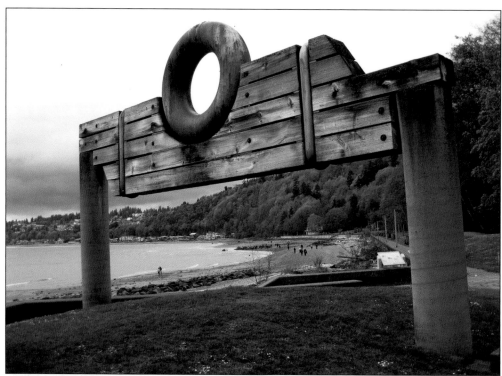

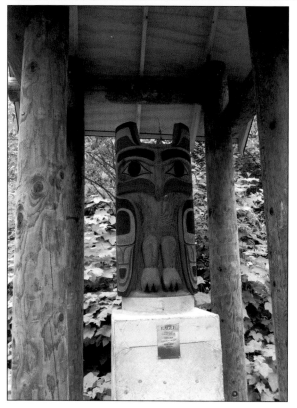

The steel, cedar, and concrete sculpture affectionately known as "The Donut" by many local residents was actually named *Taurus* by its creator, Thomas A. Lindsey. It was one in the series he called "prayer wheels." After standing sentinel in the weather of Seahurst Park for 36 years, the sculpture was in need of either removal or restoration. After consultation with the artist and 4Culture, the piece was deaccessioned by the King County Arts Commission and removed in 2013 in conjunction with a restoration of the north beach of the park. (Courtesy of Christopher Wright.)

Working in a Northwest Coast Native American style, local sculptor Galen Willis carved this eagle out of western red cedar and generously donated it to the parks department for installation at Eagle Landing Park. Tragically, after less than four years in the framework shelter at the entrance of the park, the 44-inch-tall sculpture was stolen. It remains missing today.

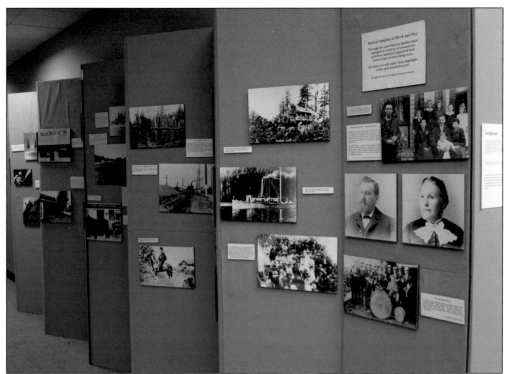

Burien is home to the Highline Historical Society, focused on preserving and documenting the history of the highline region, with a lot of attention on Burien specifically. Since its formation in 1993, the society has amassed an incredible treasure trove of local history in the form of artifacts, documents, photographs, and oral histories. Highline Historical Society curates displays of materials and information from its collection, making them available for view by the public in different locations, including the Burien Community Center.

Highline Historical Society's award-winning exhibit Hope in Hard Times was installed in an empty storefront, transforming it into a museum space for the public. Collections manager Nancy Salguero McKay expanded a traveling statewide exhibition with items and information from HHS's own collection to show the universal challenges as well as the region-specific difficulties that people faced during the Great Depression. (Courtesy of Robbie Howell.)

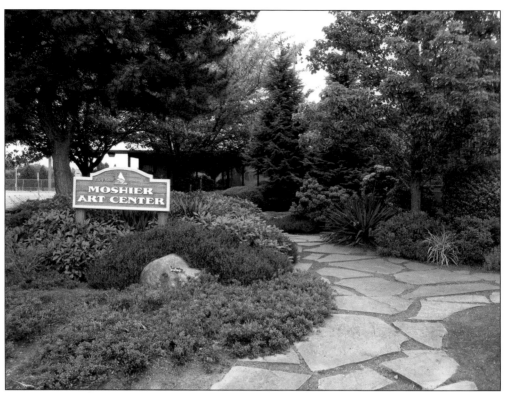

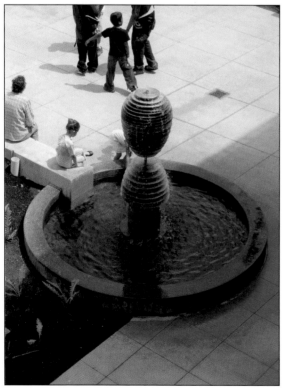

City of Burien parks department facility Moshier Community Art Center, just east of the 509 freeway, is an active working space for potters and other ceramics artists, with classes, studio space, and pottery sales. One of the most popular annual events, the Empty Bowls benefit for local food banks, is made possible through the hard work of cultural arts supervisor Gina Kallman, with help from an army of bowls donated by Moshier potters.

George Tsutakawa's fountain was originally installed in the courtyard of the old library building, which has since become the Burien Community Center. When King County relocated the library to Towne Square, the fountain was moved, too, and installed outside near the parking structure. Soon after installation, it became clear that the fountain was going to be damaged by people interacting with it. After some time away from the public, the fountain reemerged on the inside of the library behind protective panels.

The Art Alley is painted over and refreshed regularly, acting as a deterrent against graffiti. The alley is a dynamic part of the monthly B-Town Beat art and music walk. Held in various spots in the downtown core, local visual artists show their work in businesses, and local musicians perform outdoors and in establishments. (Courtesy of Robbie Howell.)

The monthly B-Town Beat always includes multiple opportunities for community members to experience the joy of creating their own works of art. Businesses provide the space and materials, and art-walkers provide the art. (Courtesy of Robbie Howell.)

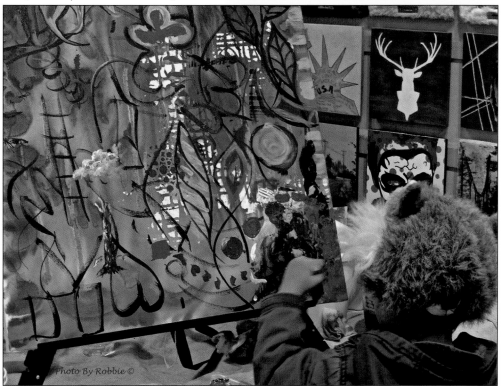

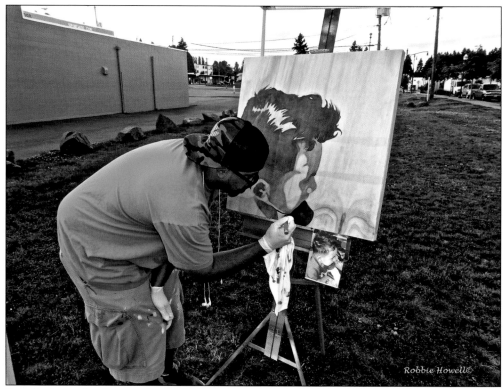

Sam Sneke is a local artist whose work is featured in various places around town, including on the wall behind Burien Press coffee shop. Sneke acts as the main organizer of the Art Alley project. Here, he performs a painting demonstration during one of the first B-Town Beat events, working with a surface much smaller than his usual canvas—the outer wall of a commercial building. (Courtesy of Robbie Howell.)

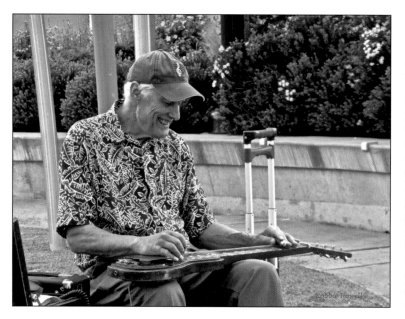

During the B-Town Beat, all kinds of artists and performers come out to show the community what they are passionate about. Here, Mike Dormann plays his slack-key guitar, performing his "Soft Island Sounds" within the Town Square sculpture Helios Pavilion. (Courtesy of Robbie Howell.)

Four

FESTIVALS AND CELEBRATIONS

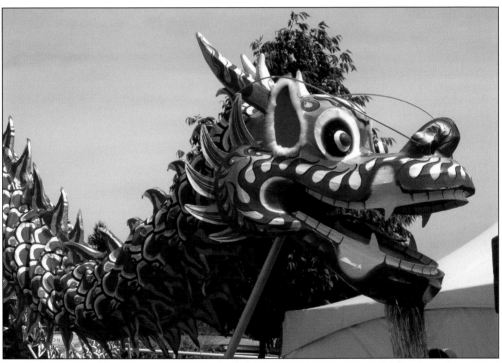

Burien is blessed with an abundance of festivals and celebrations, some of which are regular annual events, while some are one-time events. Festivities include everything from Independence Day fireworks and parades to a "Lion and Dragon" dance presented by martial arts troupe Vovinam-Viet Vo Dao Association from White Center during the Wild Strawberry Festival in 2013. Drummers provide the rhythm for the dancers as they wind the dragon and lion figures through the crowd.

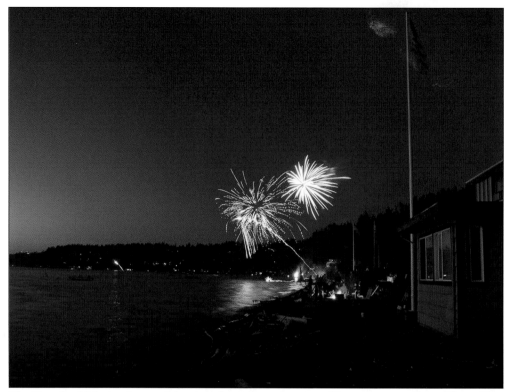

The Fourth of July is a huge celebration throughout the city of Burien, especially on Three Tree Point. Historically, the residents of Three Tree Point would save up their Christmas trees to use as fuel for Independence Day bonfires on the beach. In more recent times, the fire and explosives are primarily restricted to the officially sanctioned professional fireworks show that is launched off of a barge anchored just off the point. Even so, the teeming crowds and smaller citizen-sponsored incendiaries ensure that homeowners keep an eye out for errant sparks. (Courtesy of Michael Brunk, NW Lens.)

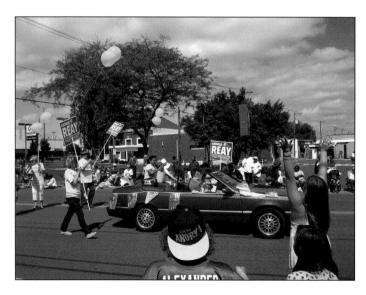

The well-attended Fourth of July parade winds its way through the center of town, featuring performing groups from schools, as well as politicians, government representatives, local organizations, businesses, and classic cars.

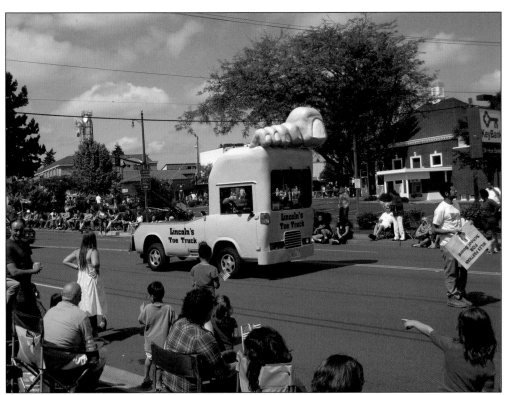

This is the right foot of Lincoln Towing Company's pair of famous pink "toe trucks." The left-foot truck was donated to the Museum of History and Industry in 2005, when the original owner of Lincoln Towing sold the business. The truck shown here is still with the company, and it occasionally gets sent to celebrations. Here, it is rolling down the street in the 2013 Independence Day parade in Burien.

The primary roads in the center of town are blocked off during the Fourth of July parade, giving people the opportunity to watch the festivities from the street. The holiday brings people from all parts of Burien together in celebration.

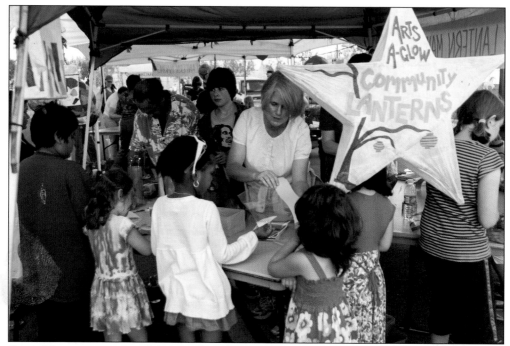

One of the core concepts of the popular Arts-A-Glow Festival is public participation. The event culminates in a community lantern parade, where anyone can join in with homemade lanterns or lanterns that they can make during the day of the festival. In the weeks leading up to the event, there are lantern-making workshops, and before nightfall on the day of Arts-A-Glow, there is a lantern-making booth where volunteers help kids and adults make their own lanterns to carry in the parade.

Each year, Shariana Mundi works with her team of artists with disabilities to create a multitude of light-based art projects that are assembled into one big installation on the Arts-A-Glow site. Her work with the community includes the No Boundaries group shows, which have been exhibited throughout the South Sound since 1991, and the ArtAbility Faire, both of which feature the art of her students.

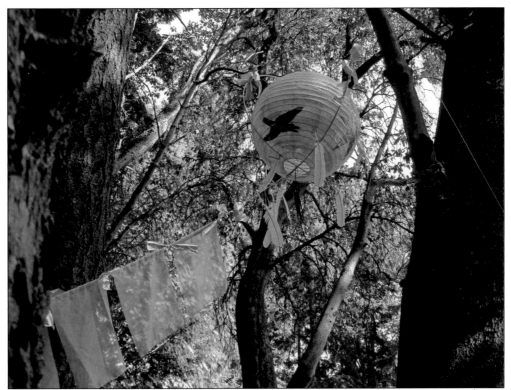

This piece by Oleana Perry, installed on the grounds and in the trees of Dottie Harper Park, is an example of the type of festive and colorful work that enlivens the park during the day of the festival. Such installations become even more spectacular after dark, when the vast, dense trees and foliage keep the city lights from detracting from these luminous works.

After dark, the park is transformed into a luminous stage of arts and performance. This photograph shows Lucia Neare's crew getting ready for the start of "Lullaby for Dottie Harper Park," the giant spectacle of dancers and singers she staged in the lower bowl of the park and surrounding walkways in 2011.

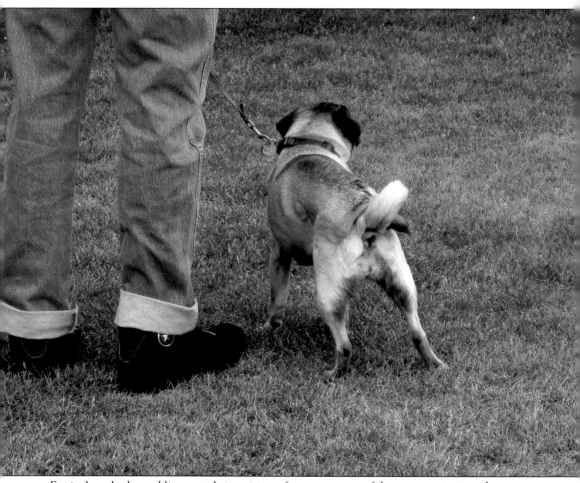

Festivals and other public events bring citizens from every area of the community into the common spaces, celebrating the rich experiences that the city has to offer. Some of these enthusiastic community members are dogs, like this pug engrossed in something interesting during the Wild Strawberry Festival.

Burien's community spirit is on display in full force at the many festivals throughout the year, including the Wild Strawberry Festival, held on Father's Day weekend. Entertainments at local festivals include performing arts, dance, food, and sometimes even acrobatics. In tandem with the Wild Strawberry Festival, there is also a Father's Day classic car show, with a wide variety of carefully maintained and/or restored vintage automobiles representing makes from all over the world and spanning several decades.

Burien's public celebrations are typically well attended—even when it rains, which is often. The events display the wide variety of people who make up Burien's citizenry. The Strawberry Festival has moved around to different locations, starting in Dottie Harper Park, then to parts of the Town Square property and Town Square Park, and spreading out to the streets and the municipal parking lot on 150th Street. The celebration's name was updated to the Wild Strawberry Festival and includes activities for all ages and a wide range of musical acts, including local school-age talent, such as these teen performers on the B-Boy Strawberry Jam stage.

Every year on Father's Day, a classic car show comes to town. Streets are closed off, allowing festival visitors to stroll through rows of cars lining the streets. Vehicles range from antique Model-Ts to 1950s Corvettes to Soviet Ladas.

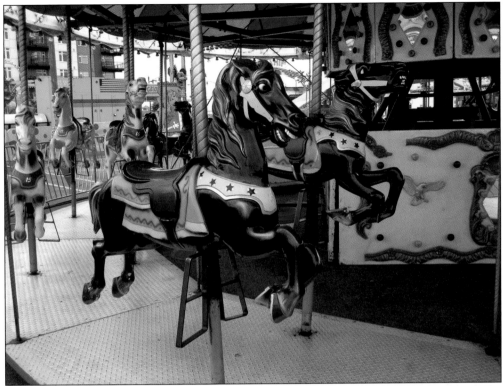

Empty lots have historically been transformed into temporary amusement parks during the Strawberry Festival. Kids of all ages can go on gentle rides, like the carousel (above), or get moved around a lot faster on one of the spinning, twirling, or roller-coaster rides (below).

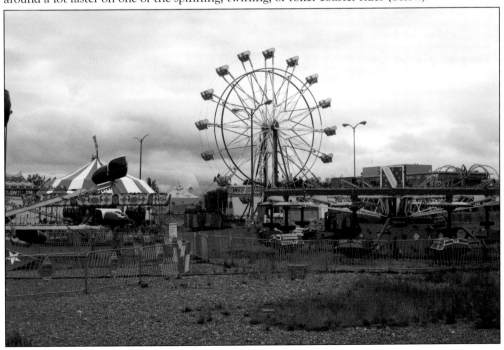

Every summer, the City of Burien sponsors a series of concerts in the park, with a wide range of musical acts, from country, to reggae, to soul, to Latin jazz. Lake Burien School Park (named after the school formerly located on the space) and North SeaTac Park provide the stages and grass, and locals bring chairs, blankets, and picnic supplies for an evening of relaxing summer entertainment.

The Burien UFO Festival provides people the opportunity to dress up like aliens and make their own model spacecraft, from small models to working drivable vehicles. Burien became more interested in the idea of aliens and UFOs when the team of people responsible for the locally produced *Maury Island Incident* film started stirring up enthusiasm.

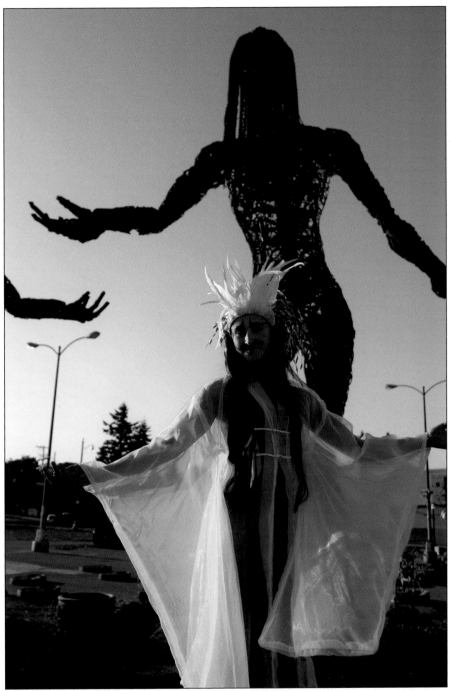

During the time that the Burien/ Interim Art Space occupied the area adjacent to Town Square, a number of festivals and community events were staged there, including the popular Arts-A-Glow festival. While the festival is centered on light-based art, a number of exciting performances and activities happen before nightfall. This photograph shows Trapecia dCabiria, one of the members of local dance/acrobatics troupe The Cabiri, echoing the form of the immense steel sculpture behind her. (Courtesy of EspressoBuzz.)

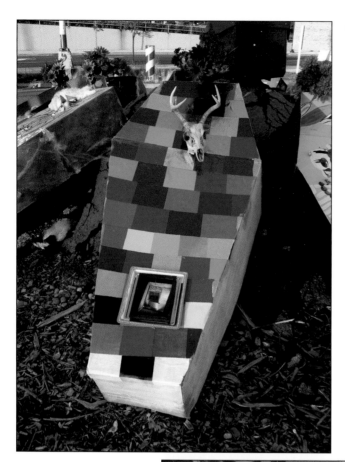

The Dia de los Muertos–inspired special art installations were on site for the Night of 1000 Pumpkins, including these elaborate and colorful coffins.

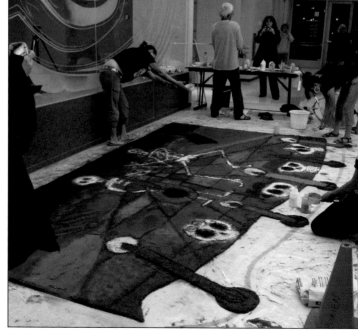

One of the many ways that A Night of 1000 Pumpkins incorporated art in many forms all over town was this temporary sand painting, executed in the lobby of the King County Library.

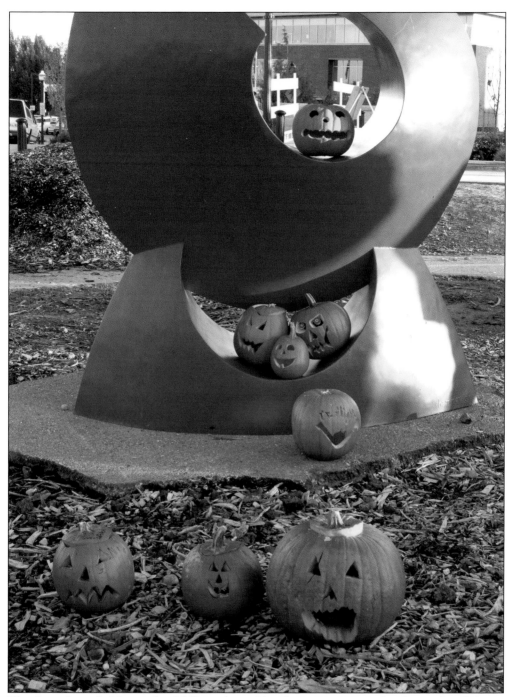

The festival was held just after Halloween, and locals were encouraged to bring their leftover Halloween pumpkins to the space, to be used as decoration or launched in a giant "Pumpkin Pachinko," later to be dumped into one enormous composting bin supplied generously by Waste Management. Hundreds of pumpkins were interspersed among the various large sculptural installations throughout the space and around the other temporary art installations brought in for the day.

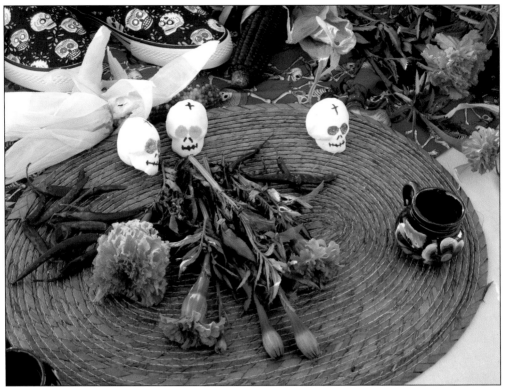

A Night of 1000 Pumpkins incorporated cultural elements of the large Latino population of Burien, including displays of traditional Mexican *ofrendas* (altars) honoring the community's ancestors. The event was a successful collaboration between the City of Burien, the Burien/ Interim Art Space, and the Highline Historical Society.

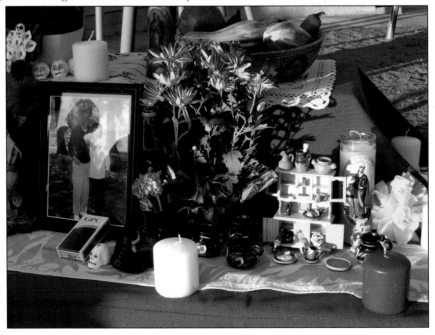

Five

A DIVERSE ARRAY OF PEOPLE AND COMMERCE

Burien has a wide range of businesses in a number of commercial districts fairly close to the downtown core. Among these establishments are retail shops, nonprofit organizations, restaurants, and healthcare providers.

Over the past few decades, Burien has seen large shifts in demographics, with increasing ethnic diversity. This influx can be seen in the names and types of businesses around town, particularly specialty retailers, groceries, and restaurants.

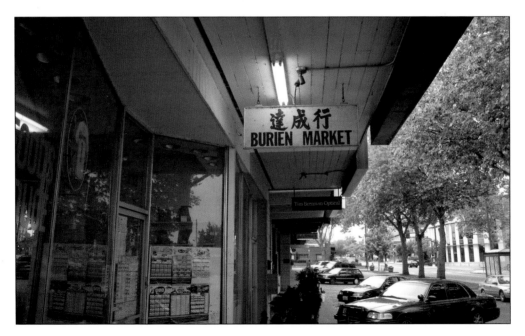

Within the very small part of town on 152nd and 153rd Streets between First and Sixth Avenues, it is possible to find restaurants and stores representing the cuisine and culture of many countries. Some of the small, specialized stores, like the bodega above on 152nd Street, have been in town for many years, while other places, like Dukem Market (right), an Ethiopian grocery and restaurant, are more recently established and reflect the more recent immigrant communities from East Africa.

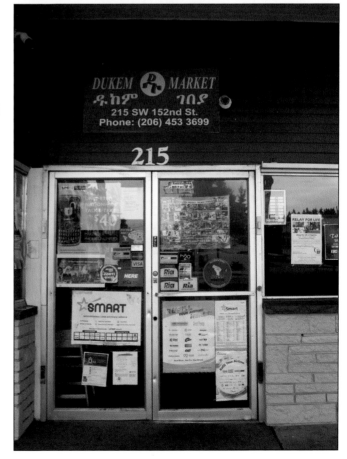

Within the central area of town, easily traversed by foot, one can find the cuisine and culture of a remarkably large number of countries. The two Halal groceries in town provide local Islamic customers (and anyone else) with food products that conform to their dietary restrictions, alongside traditional spices, grains, and vegetables. Also available are relative rarities, such as dried lemons.

Located next to each other are Alameen, a Halal market carrying Middle Eastern groceries and other items; a Baja-style taco bar; and an Indian retail store, where traditional Indian clothing and food can be purchased.

It is not hard to imagine that Angelo's Italian restaurant has looked very much the same outside and inside since the 1950s, when the Ricci family set up business in the Pacific Northwest after leaving Italy. The place, still owned and operated by the family, is popular with locals. Vince's, another longtime Italian restaurant in Burien, is almost directly across the street from Angelo's.

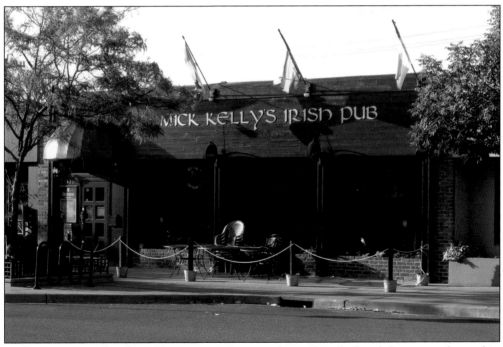

In the ever-expanding list of heritages and nationalities identified with businesses located in Burien, Mick Kelly's represents Irish cuisine and culture.

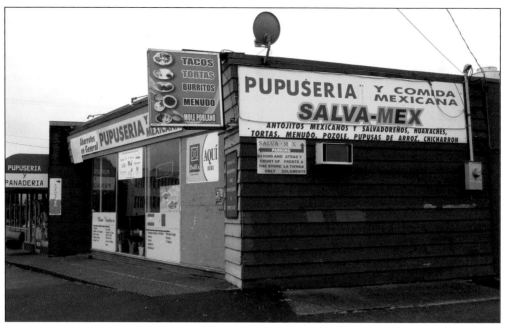

This is one of at least two Salvadoran restaurants in Burien. It serves food that is clearly and distinctly different from Mexican food, which is available less than a block away. Salva-Mex is *the* place to go to watch Mexican boxing.

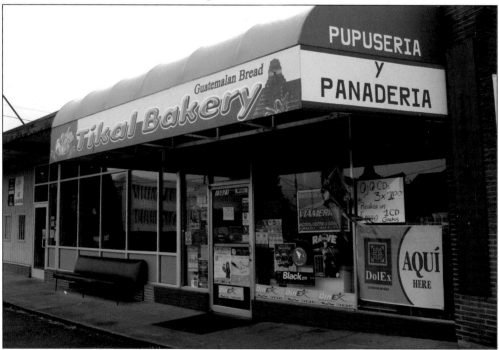

On Ambaum Boulevard just north of 152nd Street, complimenting the Salvadorean restaurant next door and the Peruvian restaurant just up the street, Tikal Bakery has brought yet another regional cuisine to town. It offers the traditional breads and baked goods of Guatemala, along with other goods from Central and South America.

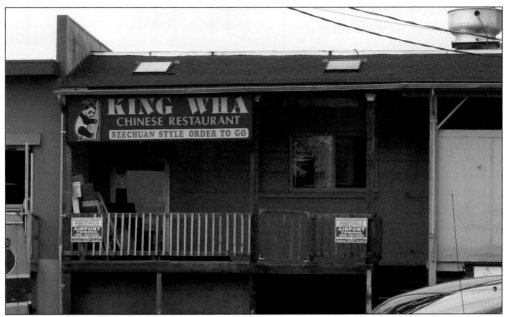

King Wha has been serving Chinese food to Burien residents since 1975.

The commercial area along First Avenue South is known mostly for car dealerships, which have been a major contributor to the Burien economy since the 1970s. For many years, car dealerships were the only draw that brought Seattle residents to Burien. But that situation is changing, as people in surrounding areas have started to realize how much the city has to offer.

152nd Street, Burien's main artery, was revitalized through a city-driven effort in 2003. Upgrades included the addition of retro-style street signs and light posts ornamented with hanging baskets of flowers in the spring and summer and holiday decorations in the winter. In addition, improvements in street parking were made. Ongoing cooperative efforts between the City of Burien, the Economic Development Program, Discover Burien Association, and the Burien Business and Economic Development Partnership work to improve citywide livability and to support economic growth and stability.

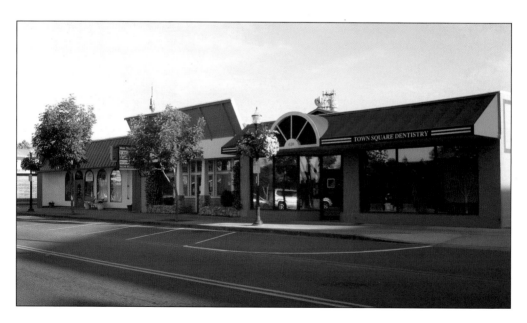

The main drag between Town Square and Olde Burien is a busy area, with a variety of shops and restaurants, as well as healthcare and wellness providers, such as chiropractic services.

Not all of the buildings in Olde Burien are old. The Elliott Building was erected in 1986 after a previous building on the same lot burned down. The above photograph shows the building just after construction, and the below photograph shows what it looked like almost 30 years later. (Above, courtesy of Steve Hughes.)

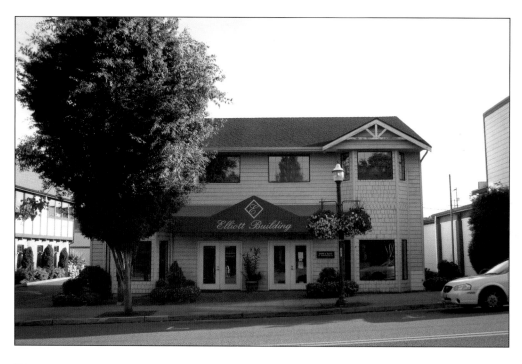

Most of Burien has very little inheritance from the cityscape that existed in the area prior to 1950. Olde Burien is the two-block exception, where there are buildings erected in the 1930s and 1940s, and a couple of structures that are even older. The area is primarily home to small retailers, restaurants, and bars, but it also includes some professional services and a massage practitioner.

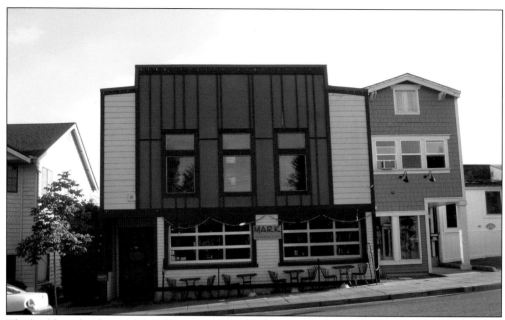

The building that houses Mark Restaurant was built in 1951. It has recently undergone significant renovation, allowing it to fit the character of the neighborhood while becoming more functional as a bar and restaurant.

Olde Burien has survived through times of growth and times of economic prosperity. There is a comforting continuity in the diverse range of small businesses housed in its charming older buildings. This building has changed very little in appearance since it was built in 1939; it is notable for its distinctive rounded windows. It now houses Burien Food Center and Phoenix Tea, sandwiched between Hayes Feed to the west and the rest of the retail block to the east.

The south side of 152nd Street in Olde Burien is characterized by old-style brick buildings with high ceilings. The center part of the building shown here housed the Danish Bakery for many years, with Viking helmets and alligator-shaped breads in its windows. It is now home to Armoire Chocolat, handmade chocolatier and purveyor of pastries.

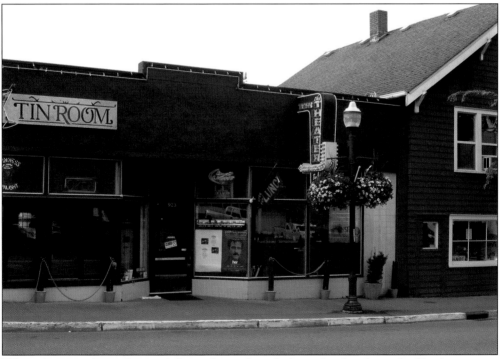

When plans were being discussed about what to do with the undeveloped parcels of land remaining in Town Square, many people advocated for a multiplex commercial movie theater. That did not happen, but Burien now has the Tin Theater, a 40-person theater that shows mostly second-run films. It is attached to the Tin Room Bar.

The Olde Burien neighborhood looks particularly ageless here, blanketed with a fine dusting of snow. During Winterfest, one of the seasonal community celebrations, horse-drawn carriages transport shoppers from one side of town to the other, creating even more of an old-time atmosphere.

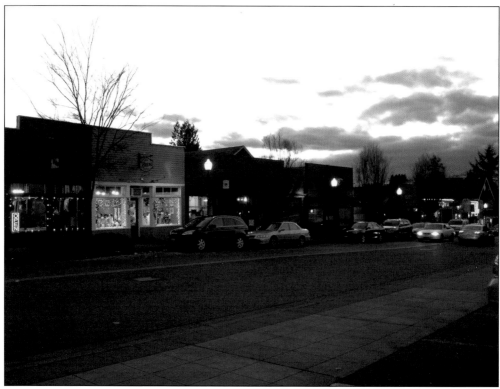

The quaint shopping district is illuminated by the distinctive Pacific Northwest dusk.

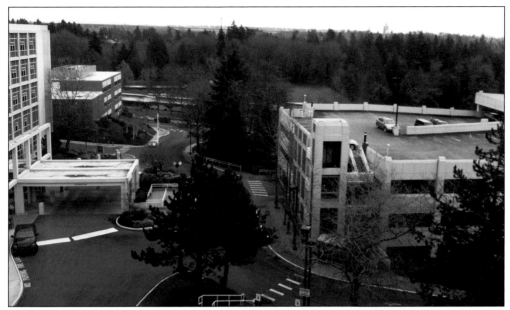

The hub of the "wellness cluster" in Burien is Highline Hospital, positioned in the southwest part of the city, near the border with Normandy Park. Surrounding the hospital and scattered through other areas in Burien are many other health- and wellness-based service providers, from naturopaths and massage therapists to fitness trainers. This sector of the economy, while providing healthcare to individual residents, provides financial wellness to Burien as a city.

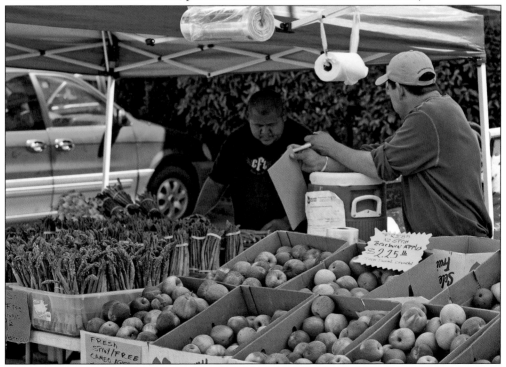

The Burien Farmer's Market is open throughout the summer and provides an opportunity to procure produce and other local products. It also features the fares of local restaurants and businesses.

Another part of town that seems to be stuck in the past is 153rd Street. The very wide street runs between businesses that would not look out of place in a photograph from the 1970s. Architecture and signage here are typical of what was prevalent at that time, and are not a result of the work of trendy retro designers. The establishments achieved their retro look through the absence of change.

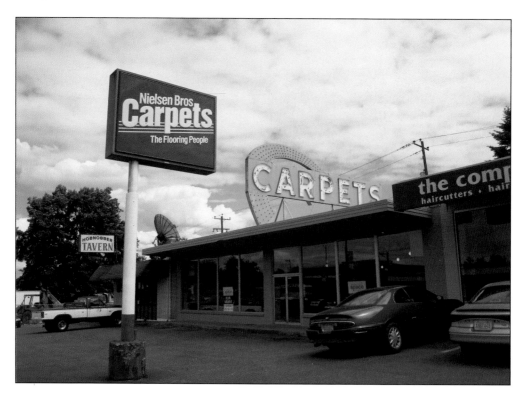

Six

DEVELOPMENT AND A
VISION FOR THE FUTURE

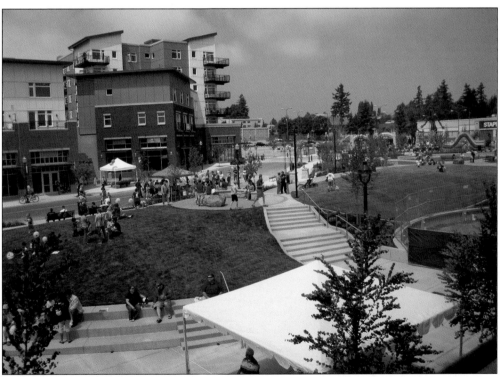

Replacing a group of stagnating and under-utilized commercial properties, the housing and retail development at Town Square reflects the exciting revitalization of the downtown core. It was originally intended to grow into a new vital heart of Burien, surrounded by small retail and restaurants, just next door to the Burien King County Library and City Hall.

Town Square's cluster of buildings was designed to become the center of the city where there had not previously been anything of substance, and it has filled that role easily. Although the economic calamity of 2008 halted progress of subsequent phases of development, the mixed-use residential, retail, and civic spaces have become increasingly more active, with increasing occupancy.

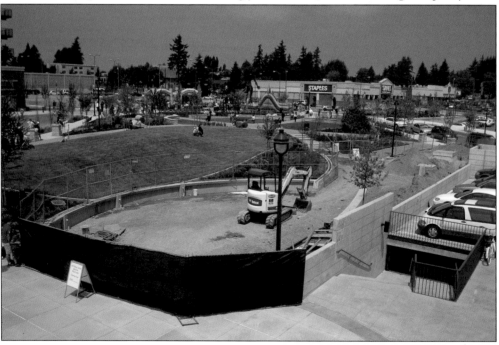

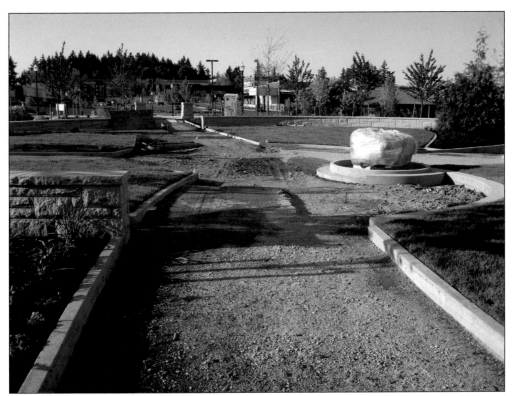

The new King County Library building and the Town Square housing and retail complex signaled a revitalization for downtown Burien, bringing the promise of growing economic prosperity. Shortly after phase I of the revitalization project was completed, the city's momentum, resources, and enthusiasm were quashed by the global economic collapse, and the building and land were tied up for years in legal wrangling between financiers and developers, delaying subsequent phases of the project until 2014.

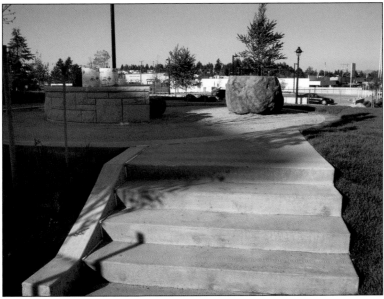

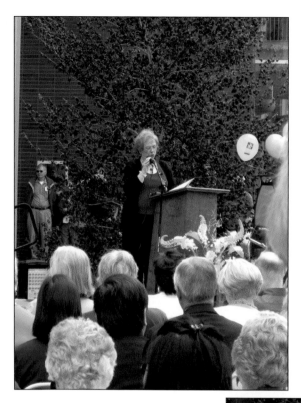

In June 2009, with a great deal of fanfare, Mayor Joan McGilton launched the grand opening ceremonies for the new City Hall and King County Library. The new facilities helped to add a more centralized feel to downtown Burien, with potential for healthy economic growth.

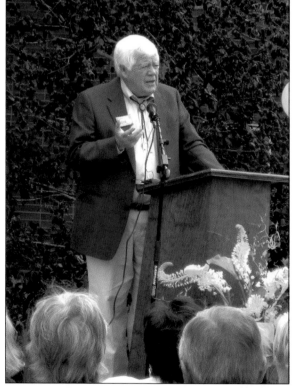

Congressman Jim McDermott spoke at the opening celebrations, reminiscing about his childhood growing up in Burien. The city is populated by recent transplants looking for the affordable, small-town feel of the city. Burien is also home to families who have been here for generations.

The Burien branch of the King County Library is one of the best in the region, with access to computers for use by the public and easy access to the 4.1 million books and other media in the King County Library system, the busiest in the country. For anyone who thinks that libraries are a dying element of a community, they need only venture into this spacious, open place filled with information to see that people still need and use libraries. There are people in the library the entire time it is open—reading, working, and relaxing.

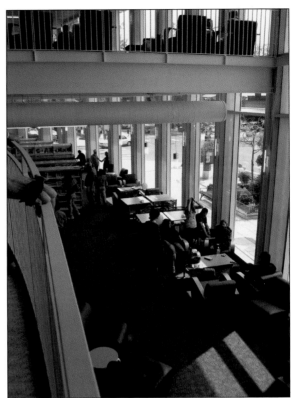

The condominiums that make up the residential component of Town Square are efficient, well designed, and represent enormous potential for a new vibrant town center with opportunities for living, shopping, and dining. At the opening ceremonies, everyone was encouraged to tour the new facilities.

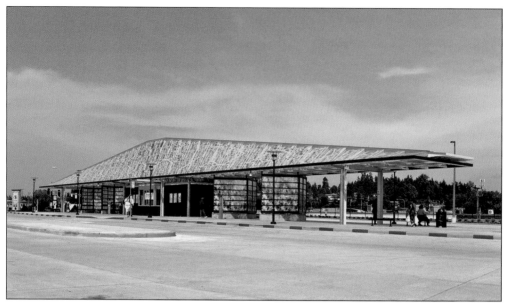

In 2009, King County Metro opened a completely new transit center in Burien, allowing for smoother commuting into and out of the city. The center is a bright, open structure, with etched-glass panels and aluminum sculptures. In 2010, the center was augmented by the addition of a multilevel parking structure, making getting in and out of Burien more convenient for park-and-ride and public transit commuters. (Above, courtesy of Oran Viriyincy; below, courtesy of Christopher Wright.)

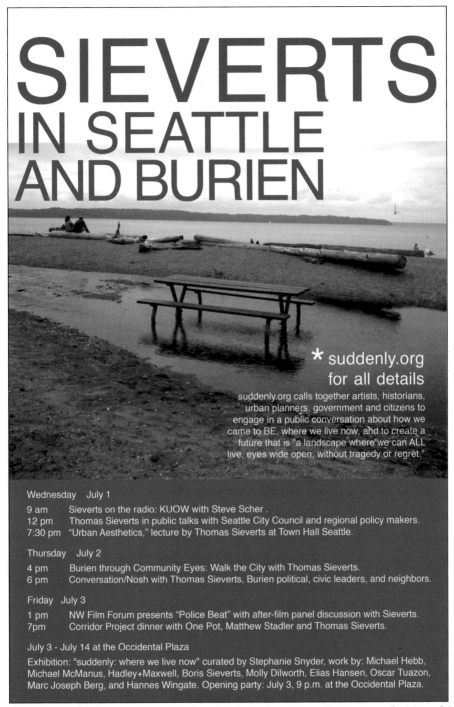

SIEVERTS
IN SEATTLE
AND BURIEN

*** suddenly.org**
for all details

suddenly.org calls together artists, historians, urban planners, government and citizens to engage in a public conversation about how we came to BE, where we live now, and to create a future that is "a landscape where we can ALL live, eyes wide open, without tragedy or regret."

Wednesday July 1

9 am Sieverts on the radio: KUOW with Steve Scher .
12 pm Thomas Sieverts in public talks with Seattle City Council and regional policy makers.
7:30 pm "Urban Aesthetics," lecture by Thomas Sieverts at Town Hall Seattle.

Thursday July 2

4 pm Burien through Community Eyes: Walk the City with Thomas Sieverts.
6 pm Conversation/Nosh with Thomas Sieverts, Burien political, civic leaders, and neighbors.

Friday July 3

1 pm NW Film Forum presents "Police Beat" with after-film panel discussion with Sieverts.
7pm Corridor Project dinner with One Pot, Matthew Stadler and Thomas Sieverts.

July 3 - July 14 at the Occidental Plaza

Exhibition: "suddenly: where we live now" curated by Stephanie Snyder, work by: Michael Hebb, Michael McManus, Hadley+Maxwell, Boris Sieverts, Molly Dilworth, Elias Hansen, Oscar Tuazon, Marc Joseph Berg, and Hannes Wingate. Opening party: July 3, 9 p.m. at the Occidental Plaza.

In 2009, Thomas and Boris Sieverts were brought from their native Germany to the United States for a series of appearances, where they discussed ideas about livable cities and urban/suburban planning. The poster shows the busy schedule of events and activities, which included Seattle and Burien and were coordinated by Suddenly.org, a group in Seattle dedicated to innovative ideas and concepts about where people live.

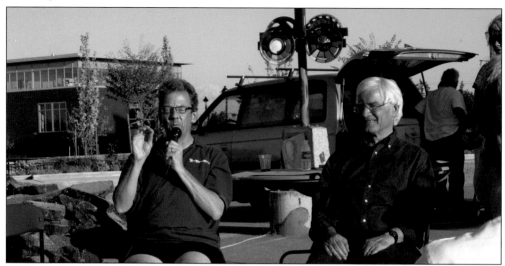

In 2009, well-known German urban conceptualist Thomas Sieverts, along with his son Boris, visited Burien to look at the city and see how it aligned with his concept of the *Zwischenstadt*—an in-between type of space, neither city, countryside, nor suburb. Accompanied by an army of engaged local residents, Thomas Sieverts walked the city, discovering hidden assets and exploring public spaces. The day culminated in a talk at the B/ IAS site, where Sieverts gave his summary of what he had found and made recommendations about the direction the city could move in. A separate exploratory session took place at City Hall, where representatives of the city council, citizen advisory panels, and the mayor talked about Burien's short- and long-term city planning. Here, B-Town Blog editor Scott Schaefer (left) engages Sieverts (right) in a discussion about the city.

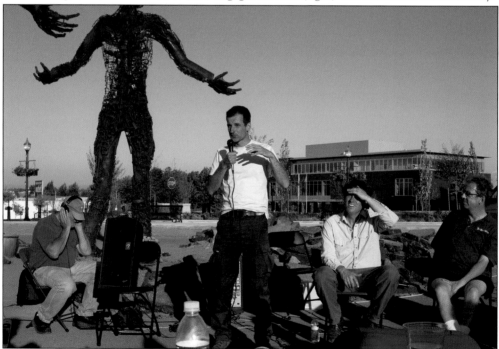

At the site of the Burien/ Interim Art Space, with the figures of *The Passage* towering behind him, Boris Sieverts speaks about the need for building livable and workable urban spaces.

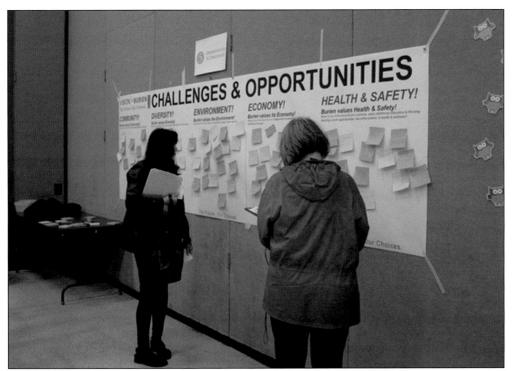

In 2011, the city initiated a large-scale visioning process to find out what was most important to residents as the city grew. There were meetings, workshops, and a lot of opportunities for Burien residents to provide input.

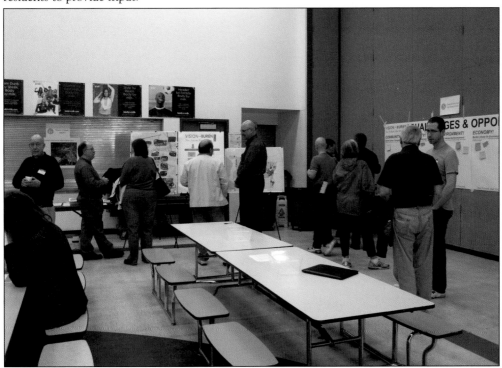

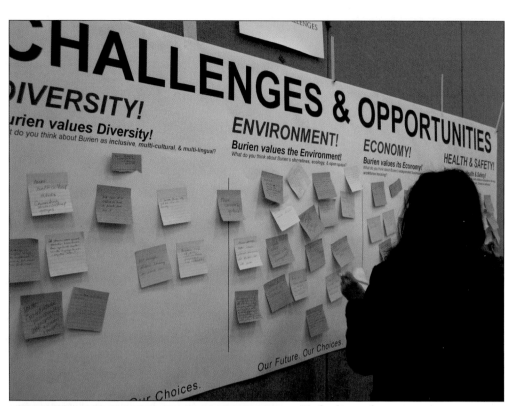

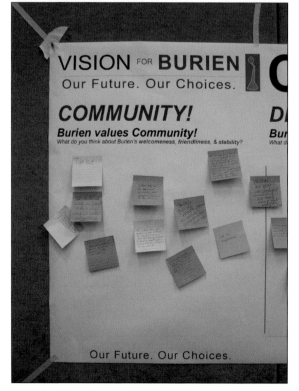

To facilitate the visioning process, the city worked with urban planner Brian Douglas Scott, who helped to organize and lead the city council and the citizens of Burien onto a more clearly defined path.

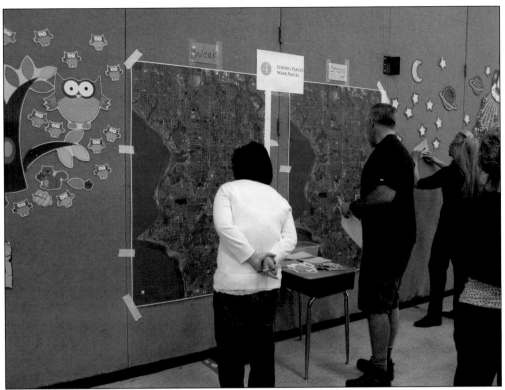

Ultimately, after many meetings, workshops, and a great deal of discussion and advocacy from individual citizens, organizations, and citizen advisory groups, the Burien City Council approved the new vision statement: "A vibrant and creative community, where the residents embrace diversity, celebrate arts and culture, promote vitality, and treasure the environment." This was then followed by an explanation of each of the core values: Community, Diversity, Environment, Prosperity, Education and Youth, Health and Safety, and Governance.

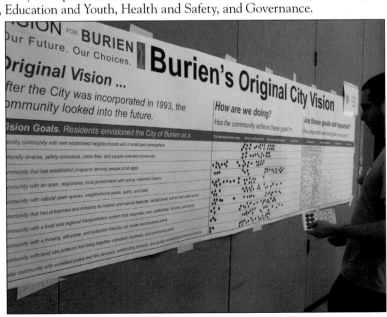

A vibrant and creative community, where the residents embrace diversity, celebrate arts and culture, promote vitality, and treasure the environment

VISION FOR **BURIEN**
Our Future. Our Choices.

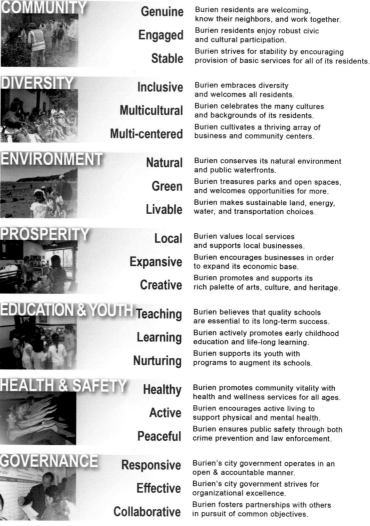

COMMUNITY

Genuine — Burien residents are welcoming, know their neighbors, and work together.

Engaged — Burien residents enjoy robust civic and cultural participation.

Stable — Burien strives for stability by encouraging provision of basic services for all of its residents.

DIVERSITY

Inclusive — Burien embraces diversity and welcomes all residents.

Multicultural — Burien celebrates the many cultures and backgrounds of its residents.

Multi-centered — Burien cultivates a thriving array of business and community centers.

ENVIRONMENT

Natural — Burien conserves its natural environment and public waterfronts.

Green — Burien treasures parks and open spaces, and welcomes opportunities for more.

Livable — Burien makes sustainable land, energy, water, and transportation choices.

PROSPERITY

Local — Burien values local services and supports local businesses.

Expansive — Burien encourages businesses in order to expand its economic base.

Creative — Burien promotes and supports its rich palette of arts, culture, and heritage.

EDUCATION & YOUTH

Teaching — Burien believes that quality schools are essential to its long-term success.

Learning — Burien actively promotes early childhood education and life-long learning.

Nurturing — Burien supports its youth with programs to augment its schools.

HEALTH & SAFETY

Healthy — Burien promotes community vitality with health and wellness services for all ages.

Active — Burien encourages active living to support physical and mental health.

Peaceful — Burien ensures public safety through both crime prevention and law enforcement.

GOVERNANCE

Responsive — Burien's city government operates in an open & accountable manner.

Effective — Burien's city government strives for organizational excellence.

Collaborative — Burien fosters partnerships with others in pursuit of common objectives.

Final Approved Vision - July 11, 2011

The keywords and statements that were ultimately adopted into the vision plan give a good summary of what people in Burien care about most. Reading even just one of the seven sections presents an idea of the whole. For example, with regard to community, the following statements were chosen: "Genuine: Burien residents are welcoming, know their neighbors, and work together. Engaged: Burien residents enjoy robust civic and cultural participation. Stable: Burien strives for stability by encouraging provision of basic services for all of its residents."

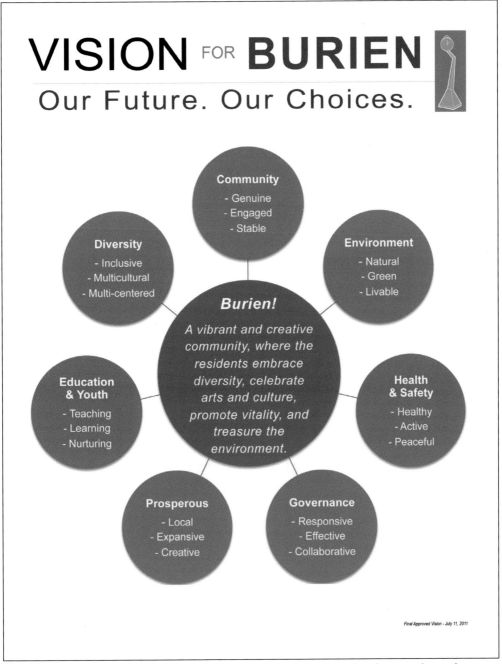

VISION FOR BURIEN

Our Future. Our Choices.

Community
- Genuine
- Engaged
- Stable

Diversity
- Inclusive
- Multicultural
- Multi-centered

Environment
- Natural
- Green
- Livable

Burien!
A vibrant and creative community, where the residents embrace diversity, celebrate arts and culture, promote vitality, and treasure the environment.

Education & Youth
- Teaching
- Learning
- Nurturing

Health & Safety
- Healthy
- Active
- Peaceful

Prosperous
- Local
- Expansive
- Creative

Governance
- Responsive
- Effective
- Collaborative

Final Approved Vision - July 11, 2011

Illustrating the final version of the plan in a more visual manner, this diagram shows the seven core concepts that Burien residents deemed most important. The graphic is an excellent way of envisioning the city. Burien itself is in the center, and the core ideas branch off from it, but none with any greater importance than any other. While there will undoubtedly be ongoing dramatic change and shifts in direction, these concepts will most likely continue as the basic underlying framework for Burien for some time.

DISCOVER THOUSANDS OF LOCAL HISTORY BOOKS
FEATURING MILLIONS OF VINTAGE IMAGES

Arcadia Publishing, the leading local history publisher in the United States, is committed to making history accessible and meaningful through publishing books that celebrate and preserve the heritage of America's people and places.

Find more books like this at
www.arcadiapublishing.com

Search for your hometown history, your old stomping grounds, and even your favorite sports team.

Consistent with our mission to preserve history on a local level, this book was printed in South Carolina on American-made paper and manufactured entirely in the United States. Products carrying the accredited Forest Stewardship Council (FSC) label are printed on 100 percent FSC-certified paper.